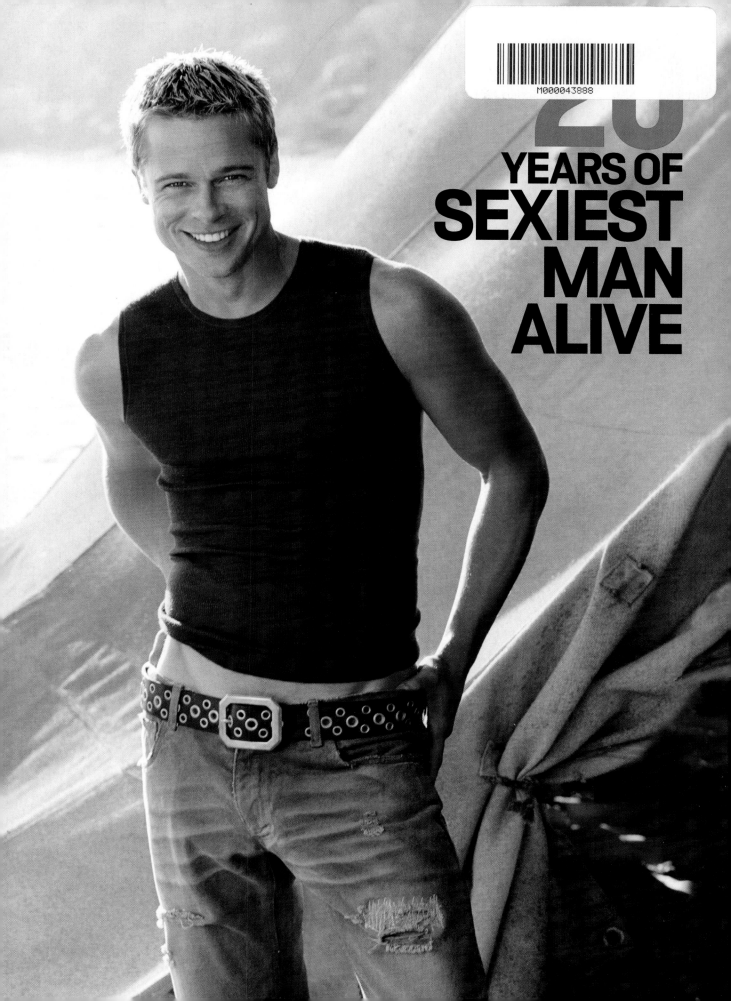

20 YEARS OF SEXIEST MAN ALIVE

CONTENTS

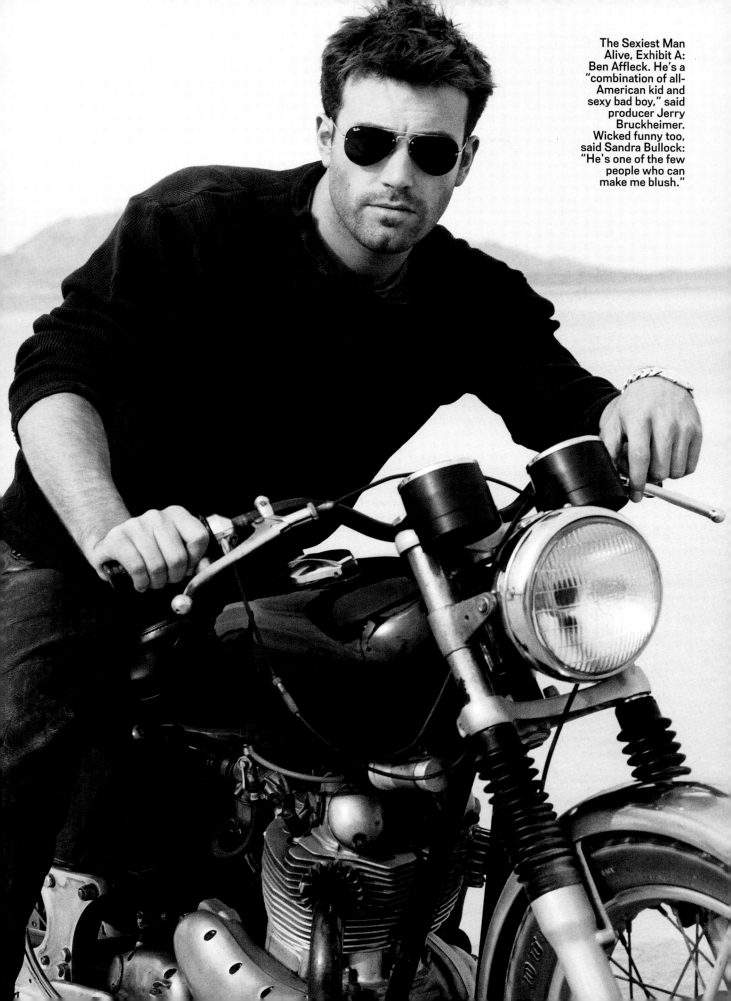

The Sexiest Man Alive, Exhibit A: Ben Affleck. He's a "combination of all-American kid and sexy bad boy," said producer Jerry Bruckheimer. Wicked funny too, said Sandra Bullock: "He's one of the few people who can make me blush."

20 YEARS OF SEXY MEN

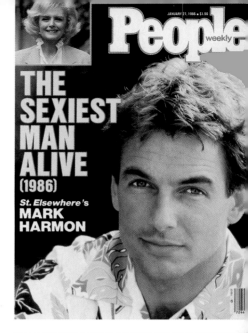

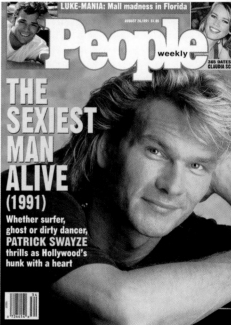

ONCE, IN A TIME OF DARKNESS, MEN OF BEAUTY WALKED UN-heralded upon the earth. Then came Mel Gibson, the Dish from Down Under, and there was a great stirring among the people and at PEOPLE, where the wise men and awfully smart women who sit in weekly editorial conferences passed among themselves photos of the azure-eyed man marvel from Oz. The air was rent by sighs and cries, including "Ooh!" "Ahhh!" and "Why don't we open a Sydney office?"

And then someone blurted, "He's the Sexiest Man Alive!"

And that, as every schoolchild knows, is pretty much how those words first appeared on PEOPLE 20 years ago: What started as a tongue-in-cheek cover line for our Feb. 4, 1985, issue featuring mesmerizing Mel quickly became the blurt heard round the world. We laughed, felt grateful for the issue's tremendous success and moved on.

And then . . . the next year we were making plans for issues, look-ing around for possible cover stories. And, like so many brilliant ideas, inspiration came not so much from genius as from memory. "Hey," said an editor. "Remember that Mel Gibson Sexiest Man cover? Why don't we do that . . . *again*?" And with one voice—a voice that, curiously, sounded a lot like Keanu Reeves in *Bill & Ted's Excellent Adventure*—the assembled editors responded,

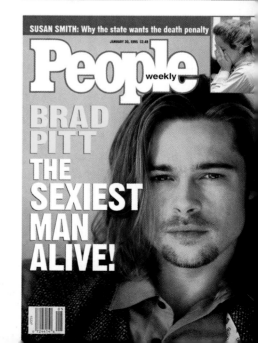

edith Baxter Birney's family ties

FEBRUARY 4, 1985 ■ $1.50

People weekly

t with
esident
y's back
ar Side's
arson

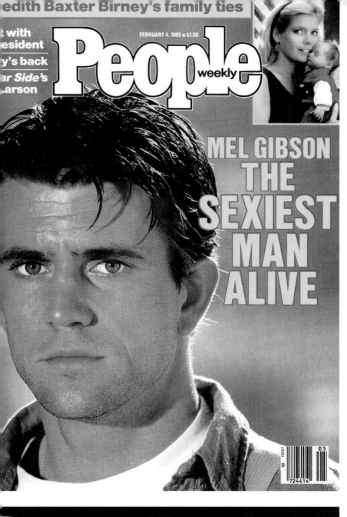

MEL GIBSON
THE SEXIEST MAN ALIVE

724414
05
0

Kate Hepburn: Memories of a maverick girlhood

SEPTEMBER 12, 1988 ■ $1.69

People weekly

John F. Kennedy Jr.
THE SEXIEST MAN ALIVE
(1988)

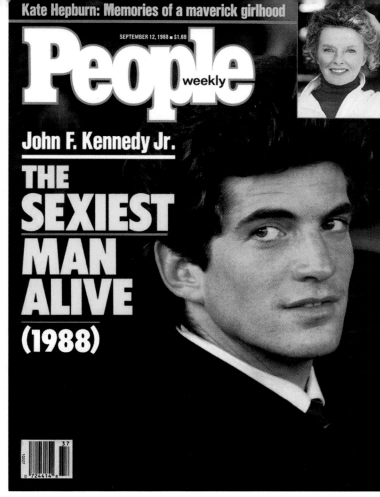

37
0 724414

JULY 23, 1990 ■ $1.95

People weekly

- The Guv and the world's richest ($1.6 million a week) soon-to-be-ex
- Abortion: Should girls have to tell their parents?

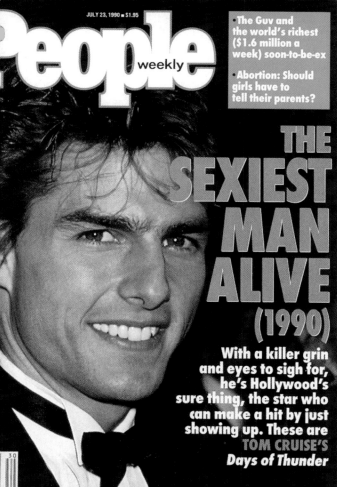

THE SEXIEST MAN ALIVE
(1990)

With a killer grin and eyes to sigh for, he's Hollywood's sure thing, the star who can make a hit by just showing up. These are TOM CRUISE'S *Days of Thunder*

30

People weekly

- Di's new nanny
- The real *Hoosiers*
- Sugar Ray's return

MARCH 30, 1987 $1.95

THE SEXIEST MAN ALIVE
(1987)
L.A. LAW's HARRY HAMLIN

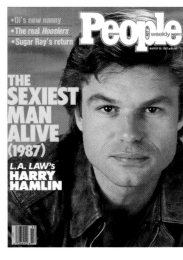

People weekly

OCTOBER 16, 1989 $1.95

SEAN CONNERY
THE SEXIEST MAN ALIVE
(1989)

Older, balder...
and better! Here's one
leading man who
doesn't need to fake it.
Plus, for the first time,
our look at 10
other contenders

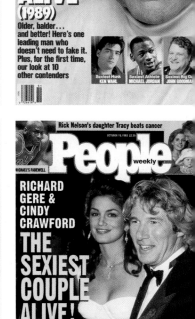

Sexiest Hunk
KEN WAHL

Sexiest Athlete
MICHAEL JORDAN

Sexiest Big Gu
JOHN GOODMAN

Who's that blonde? DELTA BURKE does Mardi Gras

MARCH 16, 1992 $1.99

People weekly

NICK NOLTE
THE SEXIEST MAN ALIVE!
(1992)

Strong, sensitive
and squared-away
at last, he's a
man's man
that women
can't resist

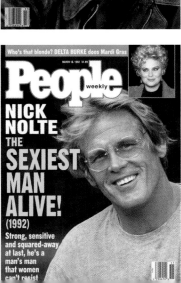

Rick Nelson's daughter Tracy beats cancer

OCTOBER 19, 1992 $2.29

People weekly

MICHAEL'S FAREWELL

RICHARD
GERE &
CINDY
CRAWFORD
THE SEXIEST COUPLE ALIVE!

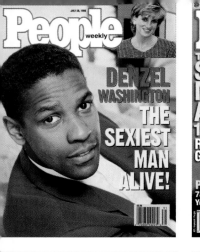

People weekly

JULY 25, 1998

DENZEL WASHINGTON THE SEXIEST MAN ALIVE!

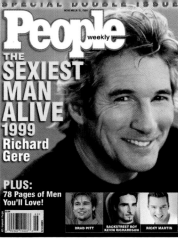

People weekly

NOVEMBER 15, 1999

SPECIAL DOUBLE ISSUE

THE SEXIEST MAN ALIVE 1999 Richard Gere

PLUS: 78 Pages of Men You'll Love!

BRAD PITT | BACKSTREET BOY KEVIN RICHARDSON | RICKY MARTIN

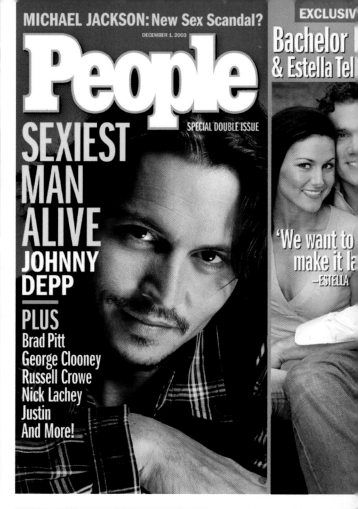

MICHAEL JACKSON: New Sex Scandal?

DECEMBER 1, 2003

People

SPECIAL DOUBLE ISSUE

SEXIEST MAN ALIVE JOHNNY DEPP

PLUS
Brad Pitt
George Clooney
Russell Crowe
Nick Lachey
Justin
And More!

EXCLUSIV

Bachelor & Estella Tel

'We want to make it la
—ESTELLA

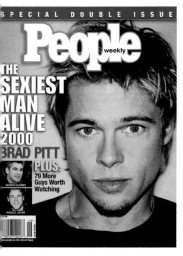

SPECIAL DOUBLE ISSUE

People weekly

NOVEMBER 13, 2000

THE SEXIEST MAN ALIVE 2000 BRAD PITT

PLUS: 79 More Guys Worth Watching

GEORGE CLOONEY

RUSSELL CROWE

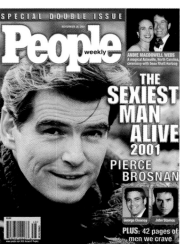

SPECIAL DOUBLE ISSUE

People weekly

NOVEMBER 26, 2001

ANDIE MACDOWELL WEDS
A magical Asheville, North Carolina, ceremony with beau Rhett Hartzog

THE SEXIEST MAN ALIVE 2001 PIERCE BROSNAN

George Clooney | John Stamos

PLUS: 42 pages of men we crave

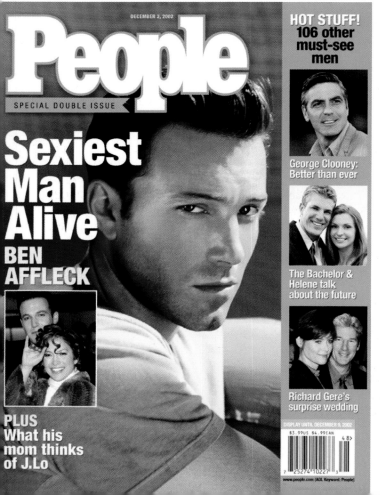

DECEMBER 2, 2002

People

SPECIAL DOUBLE ISSUE

Sexiest Man Alive BEN AFFLECK

PLUS
What his mom thinks of J.Lo

HOT STUFF!
106 other must-see men

George Clooney: Better than ever

The Bachelor & Helene talk about the future

Richard Gere's surprise wedding

DISPLAY UNTIL DECEMBER 16, 2002
$3.99US $4.99CAN
www.people.com (AOL Keyword: People)

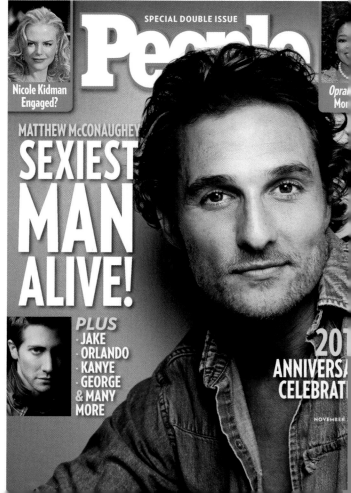

SPECIAL DOUBLE ISSUE

People

NOVEMBER

Nicole Kidman Engaged?

Oprah Mor

MATTHEW McCONAUGHEY SEXIEST MAN ALIVE!

PLUS
- JAKE
- ORLANDO
- KANYE
- GEORGE
& MANY MORE

20T ANNIVERSA CELEBRATI

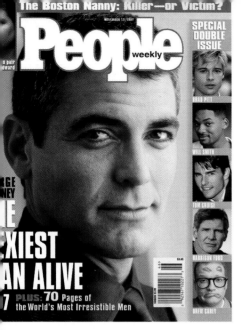

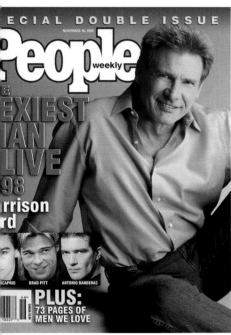

"I have to lose weight, because I've been left off PEOPLE magazine's Sexiest Man list, and it hurt!"

—1997 SMA GEORGE CLOONEY, SEVEN YEARS LATER

"Whoa. Cool. Good idea." And a franchise was born. In 1986 former UCLA football star turned dapper *St. Elsewhere* doc Mark Harmon was named Sexiest of all. In 1987 *L.A. Law*'s Harry Hamlin got the nod. As then-managing editor Patricia Ryan said at the time, "We do this for fun. Our choice is rarely expected. We select a man who is just cresting, someone you hear women in elevators talking about."

Since then, PEOPLE's Sexiest Man has taken on a tanned, smoldering, well-dressed, charming, globe-trotting, ripped, buff, perhaps waxed and usually self-deprecating life of its own. "It's true, of course," allowed Mel Gibson. "And I was just very relieved to read that I wasn't the sexiest man dead." Ben Affleck (2002) assured his mother, "Mom, it's probably a prank." She, he said, initially agreed, saying, "You as the Sexiest Man Alive? It's ridiculous, Ben! But if it's true, don't get a big head."

Most heartwarmingly, some honorees have sought to share their glory with friends. Last year two of the exalted offered a rare glimpse inside Olympus, which had recently welcomed 2004 winner Jude Law into the pantheon. "George and I have started a class," Brad Pitt (1995 and 2000) said as he and George Clooney (1997) promoted *Ocean's Twelve* with costar and SMA hopeful Matt Damon. "As former Sexiest Men Alive, we're working with the young'uns. Jude was at the top of his class immediately. He just had great flair. . . . But we've got great hopes for Matty." Promised Pitt: "Matty will get there."

Note to Matty: Keep your head high, your pants pressed and your stomach in. We care, and we're watching. The dream lives!

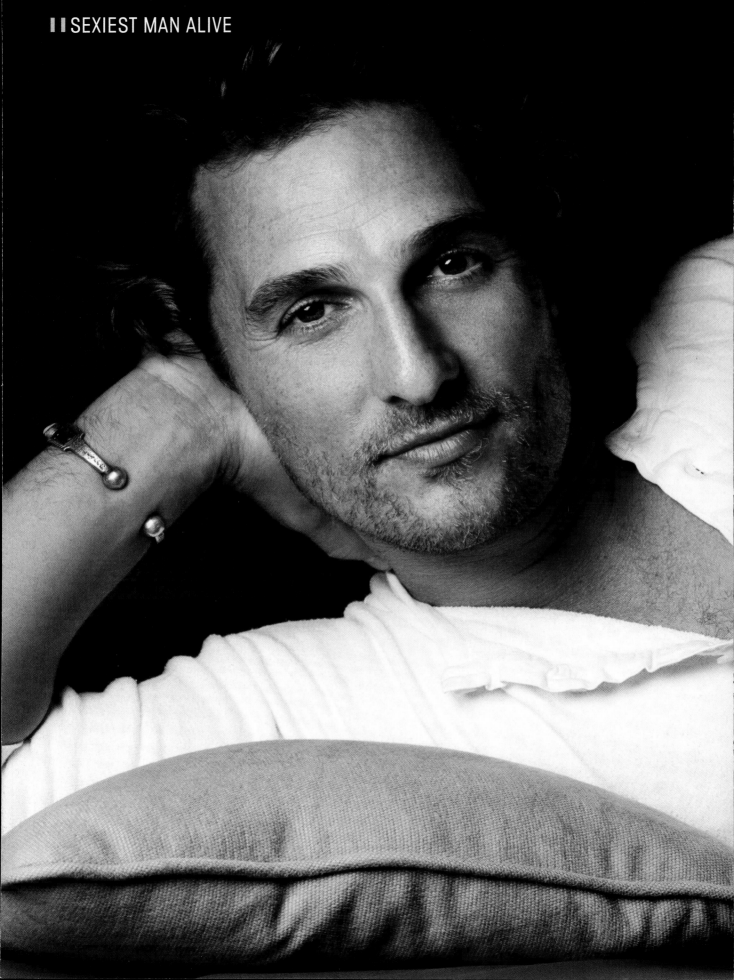

MATTHEW McCONAUGHEY
2005

Chivalrous and passionate, 2005's Sexiest Man Alive is a charmer from Texas who's even friends with his exes

Photographs by CLIFF WATTS

YSTERIOUS BROODERS WILL
always have their place among the sexy. But for sheer mood-lifting power, not much beats a guy with a twinkle in his eye. The Sexiest Man Alive for 2005, Matthew McConaughey, is a one-man endorphin rush—a Hollywood star who's happiest grilling steaks next to his Airstream camper with a can of Miller Lite in one hand, dirt under his feet and his woman (actress Penélope Cruz) by his side. But don't let the good-time rep fool you: McConaughey speaks fluent Spanish, cites the dictionary as his favorite book ("I love to look up words") and calls his mom, Kay, every Sunday. He has a sly sense of humor. Case in point: His bathrobe is monogrammed with 5'11¾", his exact height.

Loyal to friends and friends with his exes, he celebrated his 36th birthday Nov. 4 with a surprise party at L.A.'s Dolce thrown by Cruz, 31. "I had told her I wanted good food, good drink and for every single face to make me smile," he says. "And each one did."

It was a good year for the low-key leading man, whose personal motto is Just Keep Livin': He was oasis-cool in the summer action hit *Sahara*—snagging his costar Cruz along the way—and most recently held his own opposite one of his screen heroes, Al Pacino, in the drama *Two for the Money*. On this, the 20th anniversary of PEOPLE's Sexiest Man Alive title, McConaughey earned the top spot for combining Texas charm with some of the qualities of many of the heartthrobs who came before him. And now, without further ado, let's turn the floor over to McConaughey, who offers some surprising answers to PEOPLE's first-ever SAT—the Sexy Aptitude Test.

'I still remain friends with every woman I've ever really cared about'

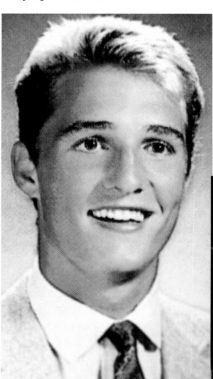

OLD SCHOOL
At Longview (Texas) High School, McConaughey (in yearbook photos) was voted most handsome. Says his mom, Kay: "He just did his thing—played tennis and golf, hung out with the guys. But I'm telling you, those girls liked his butt."

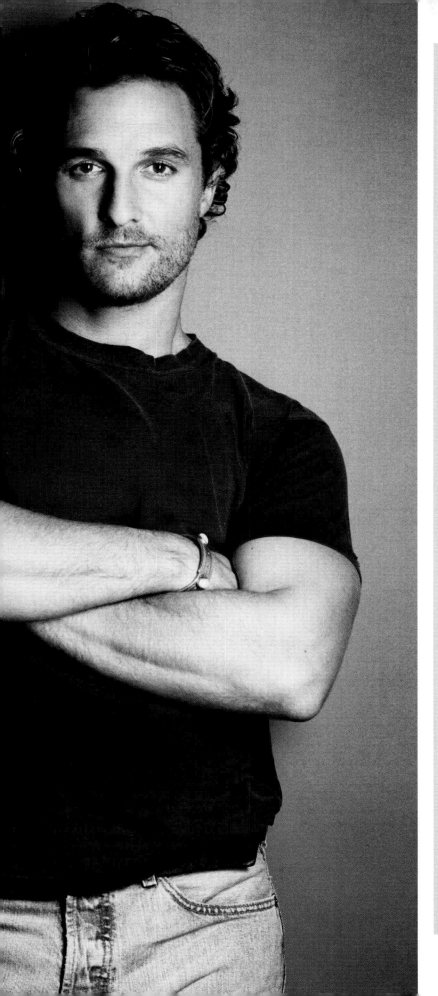

SECTION I: MATT MAKES CHOICES

Friends first or just lovers? "Friends."

PDA or behind closed doors? "I'm not much for [PDA]. I'll hold my girl. If I feel like giving her a kiss, I'll give her a kiss. But I don't care to tongue-down in public for the masses. I'll pass. That's not for everyone's display. I wasn't like that when I was 14, 15, 17, 18, 19, 20 either. I never had that need—'Hey, I'm going to show everyone this is my girl.' It's like, 'What's the advertising about?' It's the same way when you're at a party, your girl goes off, talks to someone else. If it's going to go wrong then, it was going to go wrong somewhere down the line. You can have your back turned. Actually I think it's essential to a good relationship that you have to be able to shut that kitchen door and trust that everything's cool on the other side of it."

Jealous or play it cool? "Sure, I can get a little bit jealous. The good part about jealousy is that it comes from passion. It's also the dangerous part, and it's an ugly emotion that hurts. But it's natural, sure."

Break up by phone or in person? "Always in person. I've been fortunate; I've had a lot of great women in my life and I haven't had relationships that were frivolous. It's degrading to do it by phone. Going for the straight shot—that sucks, but you don't have to look over your shoulder anymore. And if you run into that person, you don't have to sneak out the back door."

Stay friends or stay away? "I still remain friends with every woman that I've ever really cared about. I just don't know how to put Wite-Out over that period in my life. No one was lying during that time; it just didn't work out. So hopefully you're going to be inviting me to your wedding and I'm going to be inviting you to mine."

Roses or chocolate? "Neither. I don't think I've ever gotten chocolates. But I've always gotten the type of flower

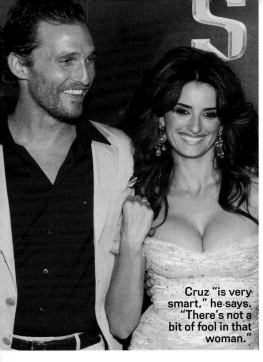

Cruz "is very smart," he says. "There's not a bit of fool in that woman."

that I know they appreciate or that represents the two of us. My mom likes a big bouquet and she always gets flowers on Valentine's Day. For Penélope, I'm not going to throw it out there, but I know what it is. I've got it down to where if that flower's there, I don't even have to put a card with it. She knows exactly who it's from—no card necessary."

Valentine's Day or any day? "For me, one of the toughest things about Valentine's Day is that it gets geared up as the day to profess your love. See, T-E-S-T—that's a bad word that doesn't go with L-O-V-E. Now, if I find a gift that goes, 'Ooh, that's her' or 'That's my woman,' I'm going to get it and I'm not going to hold onto it. I don't know how to save it. I'll give it to you on Tuesday. The tough thing is that some of my best gifts can be Tuesday in November and then come Christmas and birthday I'm going, 'I've painted myself in a corner! I can't top the last one that I gave 'just because!'"

Electric razor or manual? "Electric. I haven't used a real razor with shaving creme in probably four years. If I shave too close, I feel like all my pores close up and my face doesn't breathe too well. If I want a clean shave, my face has better texture if I shave with an electric razor, turned down to a millimeter. I really do spend time on these things."

Wax or no wax? "Absolutely not. No, no, no, never."

Take out or cook in? "I like to cook. I make a real good pasta with red sauce. All my plates are oversize. I'll put cold salad on the bottom and put hot pasta over it. Corn will be in the marinara. Garlic—that's the first thing—and then bring down the yellow onions and fresh tomatoes, and just a shot of Prego out of the bottle helps with the viscosity. It's very important—you want it to stick to the noodle. And then Italian sausage."

Beer or champagne? "Beer. I like Miller Lite or Coors Light. I would rather receive a case of beer than a bottle of 1987 Dom Perignon. Actually, out of a can is my favorite. I usually drink my beer on ice—that way you get hydrated on the way. Like me and my brothers [Michael ("Rooster"), 51, and Patrick ("Pat"), 42] say, 'We like to drink; we don't like to get drunk.'"

Jeans or tux? "Well, I like a good pair of jeans, but I also like putting on a nice tux. I'd rather go around in a good pair of jeans that you don't wash every day, because they get more and more comfortable. I've got a good pair of Levi's, 33/34s. But a good tux feels great and looks sharp. I've got a 1994 deep olive green Armani suit. When you find a good suit, it doesn't ever go out of style."

Airstream or car? Airstream. It has a few necessities: (1) A customized barbecue pit on the back. (2) A generator "if I'm not at an RV park." (3) A satellite dish. "I can get DirecTV and online wireless within 20 yards." (4) Fresh coffee. "I have this little percolator that makes the best coffee in the world. It's better than a French press, better than Starbucks." (5) A Bose stereo system. "It plays off my iTunes." (6) A custom-made bed with organic cotton-silk sheets.

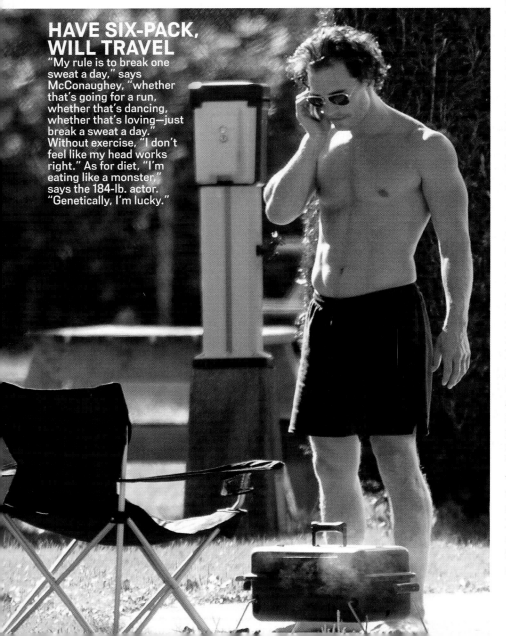

HAVE SIX-PACK, WILL TRAVEL

"My rule is to break one sweat a day," says McConaughey, "whether that's going for a run, whether that's dancing, whether that's loving—just break a sweat a day." Without exercise, "I don't feel like my head works right." As for diet, "I'm eating like a monster," says the 184-lb. actor. "Genetically, I'm lucky."

11

SECTION II: MATT FILLS IN THE BLANKS...

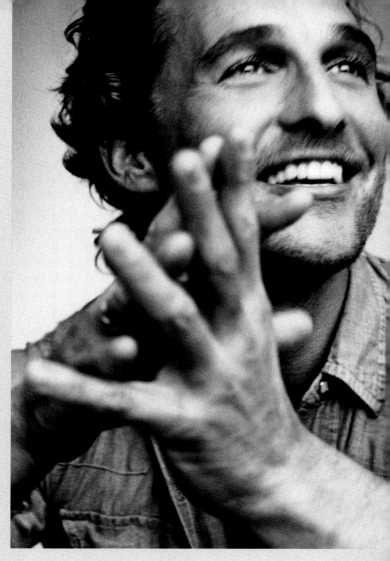

If I weren't an actor, I'd be... "A football coach. College first, but I'd be moving my way to pro."

My favorite nightcap is... "A glass of cabernet."

My favorite drink in the morning is... "Coffee. I take a tablespoon of brown sugar and low-fat milk."

My girlfriends always try to change... "You know, I guess that's why I'm not their boyfriend anymore."

A man should smell like... "A man. I haven't worn deodorant in 20 years."

I sleep in... "My bed. I'm not a pajama guy. I'm not much of a boxer guy either." So, naked? "Yes."

My worst habit is... "The Skoal [chewing tobacco] is not a great habit. Nicotine. I'll have a cigarette."

People are always surprised when I... "Make my own face and body creams."

Women can't say no when I... "Really mean yes."

If I were lost in the woods with nothing but an Army knife, I could make a... "Life for myself. I'd need to find fresh water. I've got no trouble making a tree house."

At a party I can't wait to... "Have a cocktail."

With cocktail in hand, I... "Look forward to how good the music is because I will be the first to find the groove. I mix some salsa moves in. No lessons; all freestyle."

I feel most comfortable when... "I'm on the road, behind the wheel. And you can have the best sound system in your house, but I'll grab a beer and go out and sit in my car in the driveway and just jam. Sometimes the sunroof is open."

The movie that makes me cry is... "*King Kong* with Jessica Lange. I remember crying at how much he loved her, but he was an ape, he was the outcast. He didn't know."

The last time I cried was... "Three weeks ago. I was watching something on the Discovery Channel. This guy had gotten out of prison and was talking about rehabilitation. He was so honest about it, and that made me cry."

My father [Jim, who died in 1992] always taught me... "Don't say 'can't' and don't lie. Always say 'Yes, ma'am' and 'No, sir.' My first whupping was when I told my brother Pat I hated him. My dad said, 'You never hate anything.' I haven't hated anything since."

My mother [Kay, 73] always told me... "If you woke up and you were in a bad mood, she'd make breakfast and say, 'You come in here when you're ready to see the rose in the vase and not the dust on the table.'"

I feel sexiest when... "I'm my own best friend. When I have nothing to prove."

Every guy should... "Know how to say what he can do and do what he says."

When I look in the mirror, I see... "My mom and my dad. I'll see lines and say, 'Those are good smilers, man.' But most of the time I see my best friend."

My hero is... "Me in 10 years."

My buddies always tease me about... "I have my own vocabulary. I love linguistics. That surprises people."

I'll get married when... "I'm with the right woman and it's the right time. Have I met the right woman already? Maybe. Has it been the right time? Obviously not."

When I do, I see my wedding as... "A union. I question marriage altogether: What does it really mean? The same thing that is beautiful is also what's scary. It institutionalizes it, but we want the ritual. Hey, this is our communion, in front of our loved ones. I'll say this: I may have some women lined up as my best men!"

As for kids... "Yeah, I see family. I love kids. When it happens, I know I'll be a good dad. I look forward to it."

A perfect night with Penélope is... "She loves to eat good food too. We get online or talk about some place we dream of traveling somewhere. And she loves to play blackjack. I dealt blackjack the other night. I walked away with her money. She owes me."

Chivalry is... "Never out of style. Part of a real Texan likes a woman who respects and appreciates that."

The sexiest smell is... "Yourself. The way my woman smells when she wakes up in the morning, no perfume on. But I also love honeysuckle. You walk by and it hits you and you just look for the bees."

I get turned on by... "Grace. When a woman is graceful, you can tell by the way she moves. Grace comes from comfort."

Penélope can get me out of a bad mood... "By laughing at me. She's like, 'Ah ha ha ha ha!' and I'll say, 'Stop it!' And she says, 'I'm not scared of you.' She's very smart that way. She loves to talk about both sides and have opinions."

Upon hearing that you'd been selected as the Sexiest Man Alive... "I like the 'Alive' part. Now I've made it. Wait until you see the roles I could take after this. You're going to see my gut hanging over, plus 22 [lbs.]. It'll be a whole new kind of sexy!"

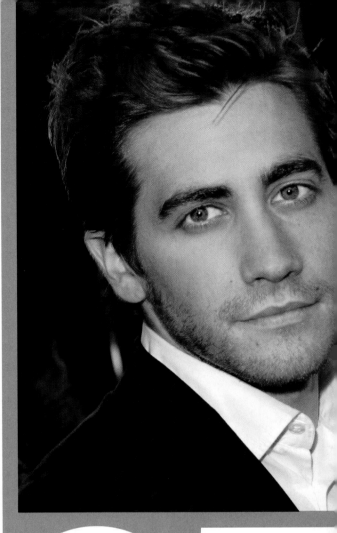

WHO WAS SEXY IN

2005

One *Lost* boy, two guys in uniform, and everyone's favorite wedding crasher took the cake

JAMIE FOXX
What did women like best about the newly minted Oscar winner? "That I'm confident and funny," said the *Jarhead* star. "I got the jokes and everything like that, and I think that if you're confident, and you're poppin' with Kanye West and you had the No. 1 song in the country ['Gold Digger'], that makes it a little sexy."

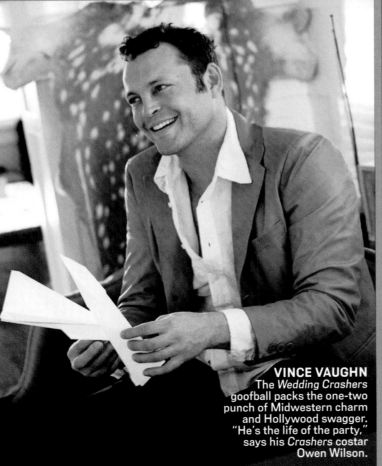

VINCE VAUGHN
The *Wedding Crashers* goofball packs the one-two punch of Midwestern charm and Hollywood swagger. "He's the life of the party," says his *Crashers* costar Owen Wilson.

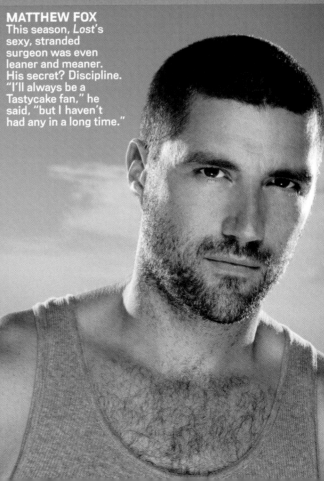

MATTHEW FOX
This season, *Lost*'s sexy, stranded surgeon was even leaner and meaner. His secret? Discipline. "I'll always be a Tastycake fan," he said, "but I haven't had any in a long time."

A SEXIEST MAN ALIVE REMEMBERS

by Patrick Swayze

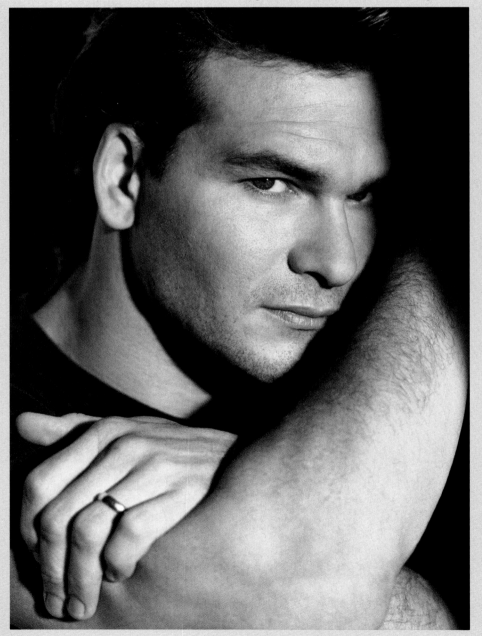

WHAT'S SEXY? I DON'T LIKE to try to define it because it's not something you can play. It's who you are or it's not.

There are so many layers to it. I think it changes on the surface, but never in its essence. No matter how one might try to cover up sensuality, it exudes from every pore. It's all in the eye of the beholder. Everybody's tastes, fantasies, needs and desires are different. What blows one person's skirt up isn't going to do it for someone else.

I look at all these other guys, and I see it. There's something—a sense of aliveness. A fire in their eyes. It's easier to see it looking at the other guys than myself. The "Sexiest Man Alive"? I thought, "I'm the same jerk that couldn't get a date in high school." When it happened, I pulled away and buried myself in acting classes. The worst thing you can do is believe your own publicity. The moment you believe the hype, it's over. If you can live through this Sexiest Man thing and hang on to your soul, the rest of your life can be wonderful when you gain a little wisdom.

With men, sexiness comes from a certain power, a certain manliness. Growing up in Texas with a cowboy father

"I'm the same jerk that couldn't get a date in high school"

—PATRICK SWAYZE

who fell in love with my mother, a big-city choreographer, I've always had that seriously manly side—that mountain-man thing—and certain standards of what a man should be. I'm also romantic to a fault. My wife and I recently celebrated our 30th wedding anniversary with an incredible trip to Alaska. I like the concept of making a commitment in a relationship. God knows relationships go up and down, but a commitment is a commitment. I like people who believe in what they believe in and stay true to it. To me, the sexiest thing in a woman is a real level of truth. Real honesty.

In my career I've always searched for characters who are torn between what society tells them and what their hearts tell them. I'm attracted to realistic heroes. I've always wanted to do the roles that capture my idea of what a hero should be. They're not perfect. In *Dirty Dancing,* I believe it's not Patrick Swayze's swinging his hips; it was the character's heart that drew the audience in. I've always felt that if people believe you and believe that you will not be complete until that other person is in your life, it passes the goose-bump test and lets other people go on the journey with you in the film.

I really feel that if you stay true to who you are and your desire to contribute something to the world it will pay off, even if you're 80 when it happens. Here I am at another stage of my career. People are buying *One Last Dance,* the film that took years for my wife, Lisa, and me to get made. Fans have been fans for so long. That must have something to do with the "Sexiest Man Alive" stuff. It makes my heart feel good. In that little place inside, it's hugely validating.

...AND 15 OTHERS LOOK BACK

"It's true, of course. And, I was just very relieved to read that I wasn't the sexiest man dead"
—MEL GIBSON

"Listen, who wants to be the standard of comparison? It's some cruel and heinous joke. A friend of mine said they misspelled it—it was supposed to be sexiest *moron*"
—BRAD PITT

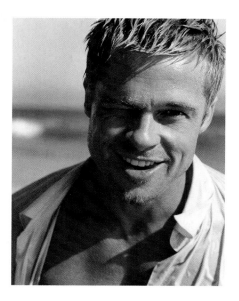

"It's not so much that it irritates me. I mean... on some level, it's flattering"
—JOHNNY DEPP

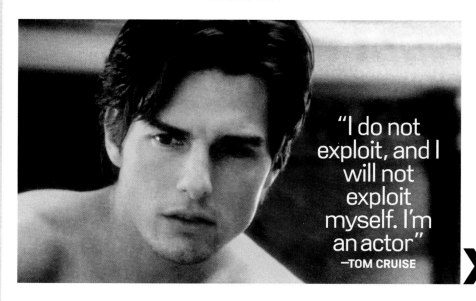

"I do not exploit, and I will not exploit myself. I'm an actor"
—TOM CRUISE

»

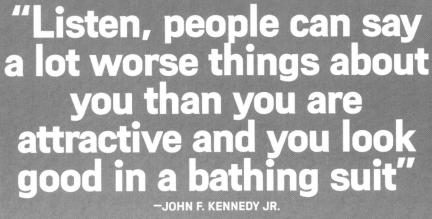

"Listen, people can say a lot worse things about you than you are attractive and you look good in a bathing suit"
—JOHN F. KENNEDY JR.

"It's quite amusing but it's ridiculous to be 51 and be called the sexiest man alive. I mean, somebody's got a twisted sense of perspective"
—NICK NOLTE

"I was in Australia and saw it on the newsstand. I thought I was going to pass out. I was so mortified that I called all my friends in L.A., begging them to be kind"
—HARRY HAMLIN

"People called my mom first. So Mom calls me and says, 'You're the sexiest man alive?' I said, 'Mom, it's probably a prank.' Mom says, 'You as the sexiest man alive? It's ridiculous, Ben! But if it's true, don't get a big head'"
—BEN AFFLECK

"Why this sudden outpouring for geezers?"
—HARRISON FORD

"It's embarrassing... they're saying a very nice thing about you, but the connotation is always that you're an idiot or you're untalented... what it does is boxes you into roles"
—GEORGE CLOONEY

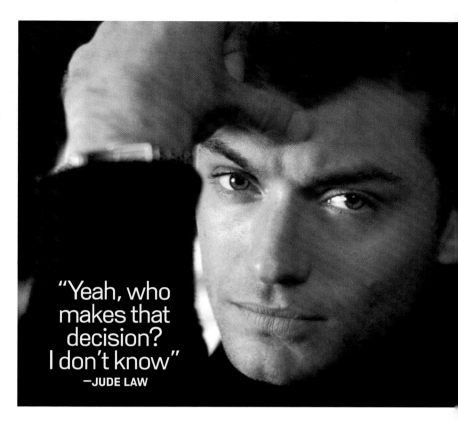

"Yeah, who makes that decision? I don't know"
—JUDE LAW

"I accept it"
—PIERCE BROSNAN

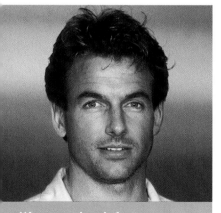

"It probably came about because they're pretty hard up for sexy men and my publicist is doing a good job"
—MARK HARMON

"I think it's very nice, and needless to say, my wife is thrilled, but I'm getting kidded to death"
—SEAN CONNERY

"I don't really like that kind of stuff. Nobody was saying that about me when I was 18, and I'm the same guy. And if you're the sexiest man alive, when do you stop being the sexiest man alive? It's cute, that's all"
—DENZEL WASHINGTON

A dash of Down Under,
a lot of over-the-top:
Ladies and gentlemen,
the man who started it all

MEL
GIBSON
1985

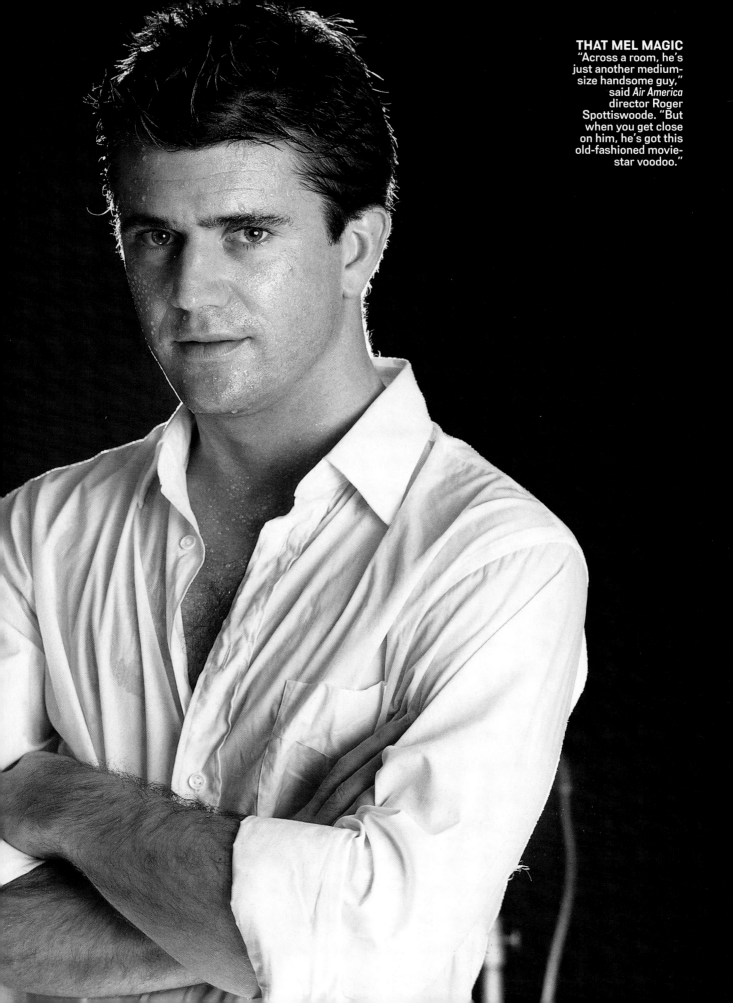

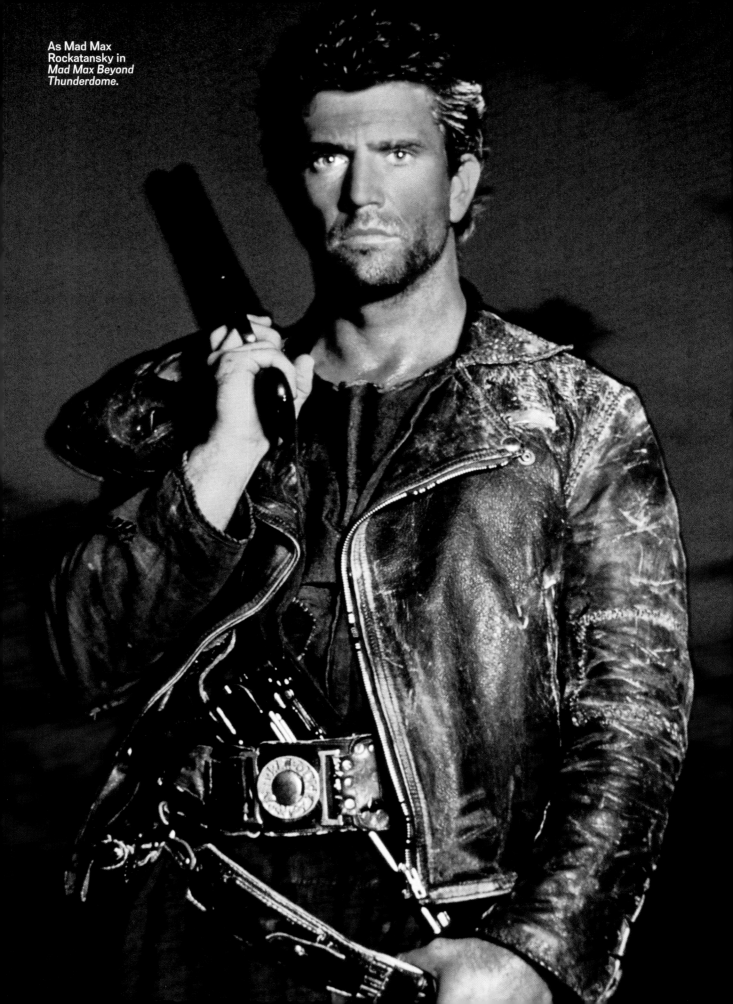

As Mad Max
Rockatansky in
*Mad Max Beyond
Thunderdome.*

The Bounty
(1984)

SURE, THERE WERE OTHER MANLY men in movies that year. Sylvester Stallone was ripped in *Rambo*. At the other extreme, Harrison Ford made even the Amish seem sexy in *Witness*. But Mel . . . all blue eyes and leather pants, kicking postapocalyptic butt in *Mad Max Beyond Thunderdome*. He was strong, he was sensitive. In leather pants. He was stubbly, he was sweaty. In leather pants. Mark Ridell, who later directed him in *The River,* predicted Mel would be "the star of the '80s."

Did we mention the leather pants?

By the time he became PEOPLE's inaugural choice in 1985, Gibson had already built up a steamy pedigree. *Thunderdome* was the third time he'd stripped down as the Road Warrior, Mad Max Rockatansky, a series that began in 1979. As for 1983's *The Year of Living Dangerously,* hands up any women who didn't want to be Sigourney Weaver? In that heat-drenched film, she and Gibson got tangled in foreign affairs. Mel was "the most gorgeous man I've ever met," said Weaver.

He was also one of the most concerned about living in the public eye. "It's as if you have your pants down around your ankles and your hands tied behind your back," he said in our cover story. Many described him as standoffish—though some simply thought of him as shy. "He's got these great blue eyes that take you in, but erect a barrier and push you away," said Linda Hunt, his *Dangerously* costar.

Onscreen his chemistry has carried him for 25 years through films like *Hamlet, The Patriot, Braveheart* (which earned him two Academy Awards) and four *Lethal Weapon*s. He's 49 now, the father of seven and married to his wife, Robyn, since 1980. He long ago stopped banking excessively on his looks: Behind the camera Mel directed *Braveheart* and, famously, put up millions of his own to produce the controversial *The Passion of the Christ*, which grossed at least $600 million worldwide, making him a Hollywood power to contend with. Next up: a possible date with an old friend. He's considering *Mad Max: Fury Road.*

Somewhere a pair of leather pants sits, waiting. ❚❚

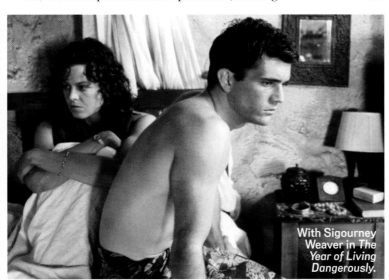

With Sigourney Weaver in *The Year of Living Dangerously.*

It's a Mad Mad Mad Mad Mel

In a 1980s encounter with a woman reporter, Gibson offered to throw himself on the floor so she could walk on him, literally. "Tell me if I'm [creepy]," he told her. "You're right. I am. Print it." She did.

While directing 1995's *Braveheart,* he surprised crew and cast with whoopee cushions, stink bombs and stunts too hideous to mention. "Some of them were pretty cruel," he said. "I can't even repeat them."

The gift that says . . . well, we're not sure: On the set of 1997's *Conspiracy Theory,* Gibson gave costar Julia Roberts a freeze-dried rat. Beautifully wrapped, though.

Wary of Gibson's rep—and, perhaps, already having all the freeze-dried rats she needed—2000's *What Women Want* costar Helen Hunt got down on her knees and begged him to spare her, saying, "Please, I'm the wrong person for this!" It worked.

TOM SELLECK
The best of the island '70s look, but without the pukka shells.

WHO WAS SEXY IN

1985

It was a year for headbands...on men...and the Boss's backside in blue jeans

BRUCE SPRINGSTEEN
Born to Run Bruce got buff for *Born in the USA*. The biceps, the headband and the . . . er . . . butt captured an American moment.

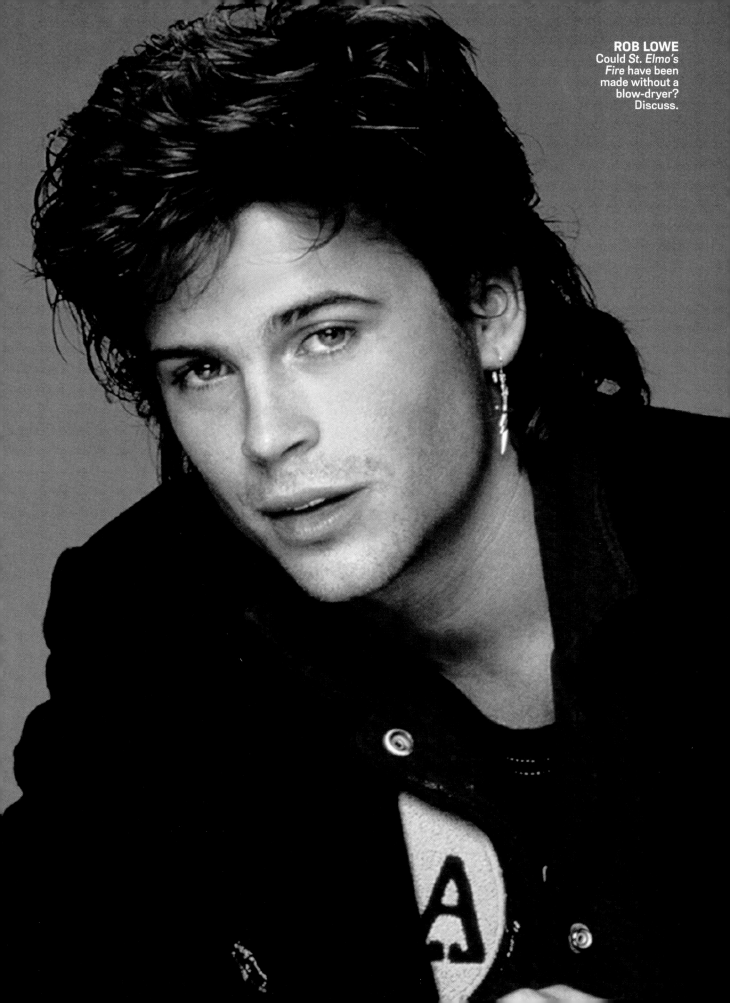

ROB LOWE
Could *St. Elmo's Fire* have been made without a blow-dryer? Discuss.

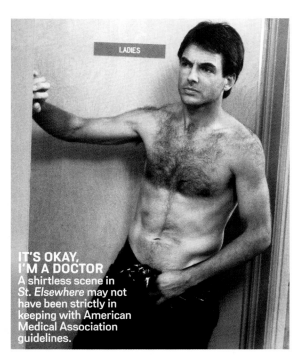

IT'S OKAY, I'M A DOCTOR
A shirtless scene in *St. Elsewhere* may not have been strictly in keeping with American Medical Association guidelines.

HE WAS NOT A DOCTOR, BUT HE PLAYED ONE ON TV, AND women responded. "Mark's made more American women hot than saunas," bada-binged comedian Joan Rivers of the *St. Elsewhere* star, who played philandering plastic surgeon Dr. Robert Caldwell. Some people had trouble distinguishing the character from the man—although he probably bore some responsibility for confusion. "Women would come up to me, show me their breasts and ask for my opinion," said Harmon, a former UCLA football hero. "And I gave it to them!"

Before he married *Mork & Mindy* star Pam Dawber in 1987 and became a dad of two, Harmon had a few steamy (and not-so-steamy) offscreen romances. In 1984, after four years with *Flamingo Road* costar Cristina Raines, he dated *Dynasty* diva Heather Locklear. Well, sort of. "It began around Christmas but was over by New Year's," he said. "[Heather was] just an emotional cup of coffee to me."

Today, the settled Harmon, 54, stars on CBS's *NCIS*. Giving props to his unassuming costar, Michael Weatherly said, "We did [a press tour] in New York . . . and these chicks went bananas for Mark. I mean, like Tom Cruise/Brad Pitt bananas." Call it sex a-peel. Or . . . maybe not.

The doctor will see you now

MARK HARMON
1986

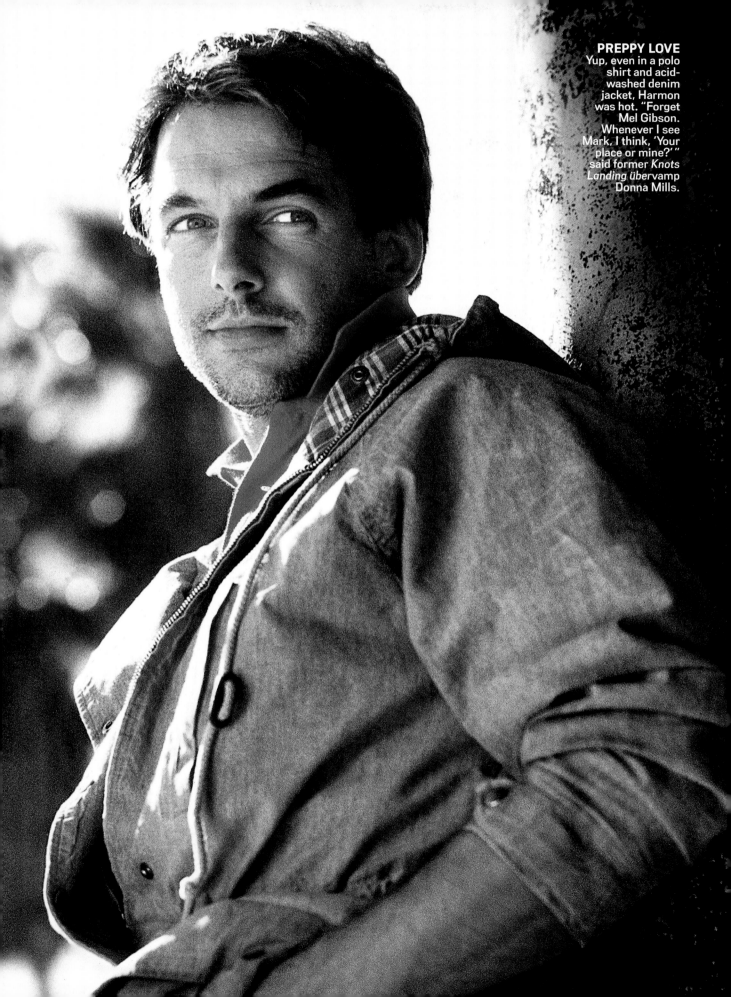

PREPPY LOVE
Yup, even in a polo shirt and acid-washed denim jacket, Harmon was hot. "Forget Mel Gibson. Whenever I see Mark, I think, 'Your place or mine?'" said former *Knots Landing* übervamp Donna Mills.

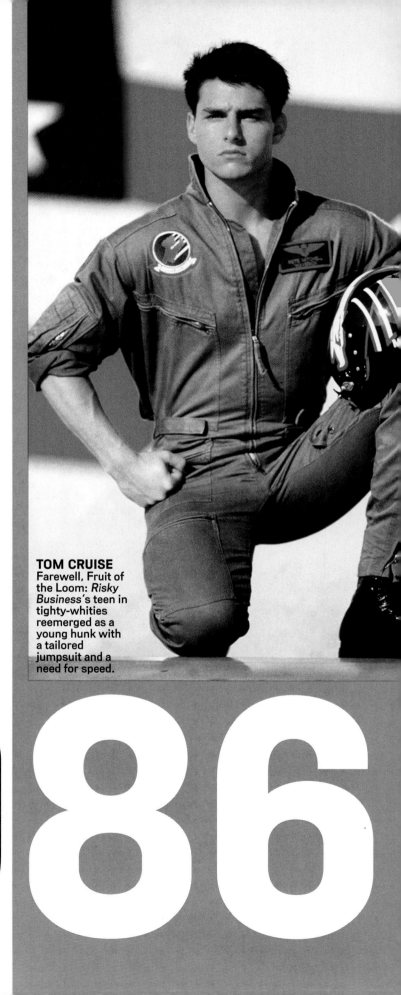

Fans flocked to two distinct flavors: Macho Flyboy or Miami Peach

WHO WAS SEXY IN
1986

TOM CRUISE
Farewell, Fruit of the Loom: *Risky Business*'s teen in tighty-whities reemerged as a young hunk with a tailored jumpsuit and a need for speed.

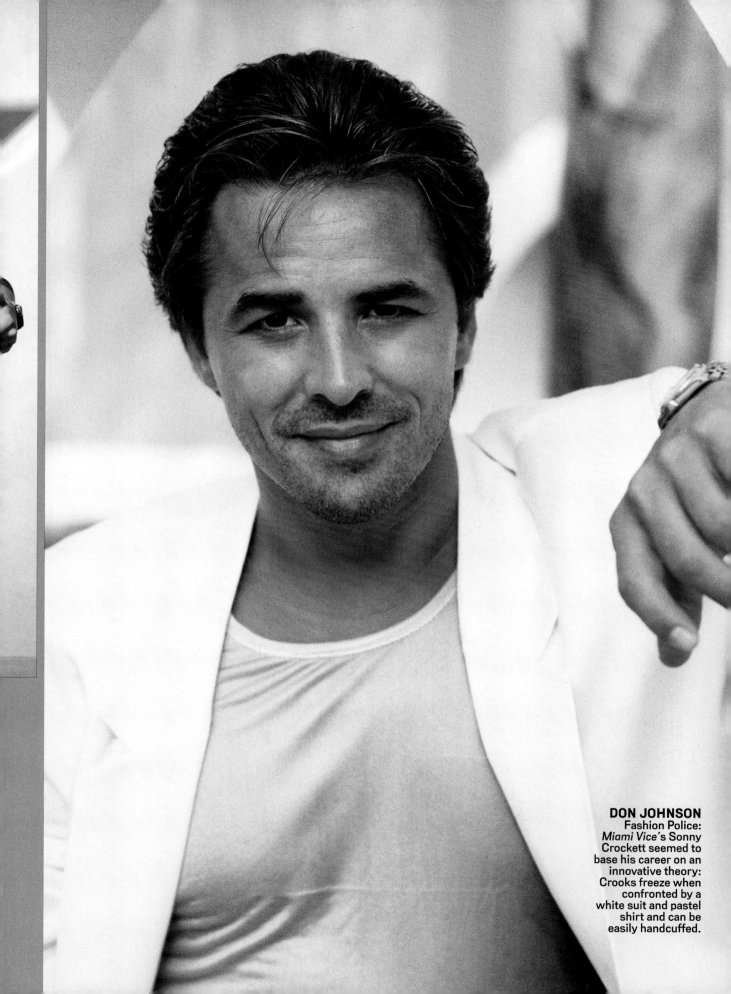

DON JOHNSON
Fashion Police: *Miami Vice*'s Sonny Crockett seemed to base his career on an innovative theory: Crooks freeze when confronted by a white suit and pastel shirt and can be easily handcuffed.

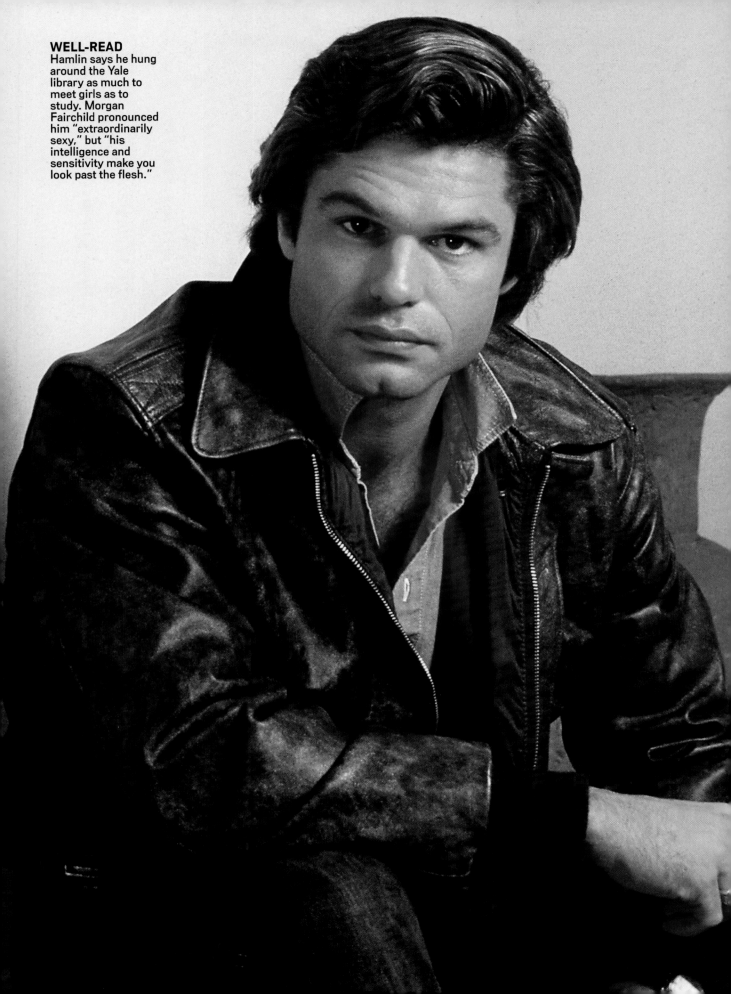

WELL-READ
Hamlin says he hung around the Yale library as much to meet girls as to study. Morgan Fairchild pronounced him "extraordinarily sexy," but "his intelligence and sensitivity make you look past the flesh."

Courtroom Casanova

HARRY HAMLIN
1987

YEAH, HE WAS SMART (GRADUATED FROM YALE) and cultured (known to enjoy champagne and Vivaldi). And, as a lustful lawyer on the TV season's new hit *L.A. Law,* he knew how to deliver a well-scripted opening statement. Throw in perfectly pouty lips and, bingo, Hamlin got that year's Sexiest Man nod. Leading ladies agreed with the verdict. "Harry is vulnerable, with an edge," said *L.A. Law* costar Susan Dey. Nighttime soap goddess Morgan Fairchild said his "intelligence and sensitivity make you look past the flesh." At 43, Swiss actress Ursula Andress may have. She and Hamlin, then 28, entwined togas during filming for 1981's *Clash of the Titans.* They lasted until 1983 and had son Dimitri; two years later Hamlin wed actress Laura Johnson. They divorced in 1990, and the actor married *Desperate Housewives* star Nicollette Sheridan in 1991, the same year he left *Law.* Hamlin split with the Wisteria Lane siren in '93 and in 1997 found his true love, Lisa Rinna, of *Melrose Place.* Since then, case closed.

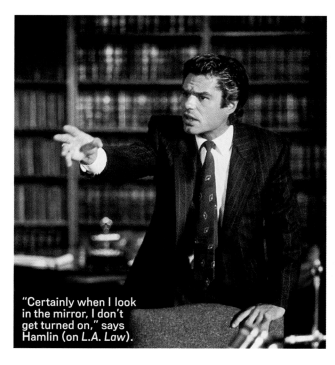

"Certainly when I look in the mirror, I don't get turned on," says Hamlin (on *L.A. Law*).

WHO WAS SEXY IN

1987

Forget the two Oscars. Michael Douglas's greatest achievement? Making suspenders sexy

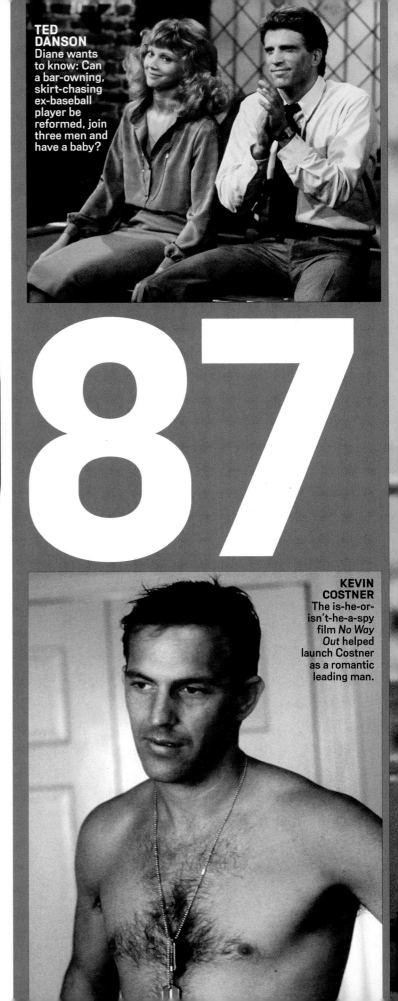

TED DANSON
Diane wants to know: Can a bar-owning, skirt-chasing ex-baseball player be reformed, join three men and have a baby?

KEVIN COSTNER
The is-he-or-isn't-he-a-spy film *No Way Out* helped launch Costner as a romantic leading man.

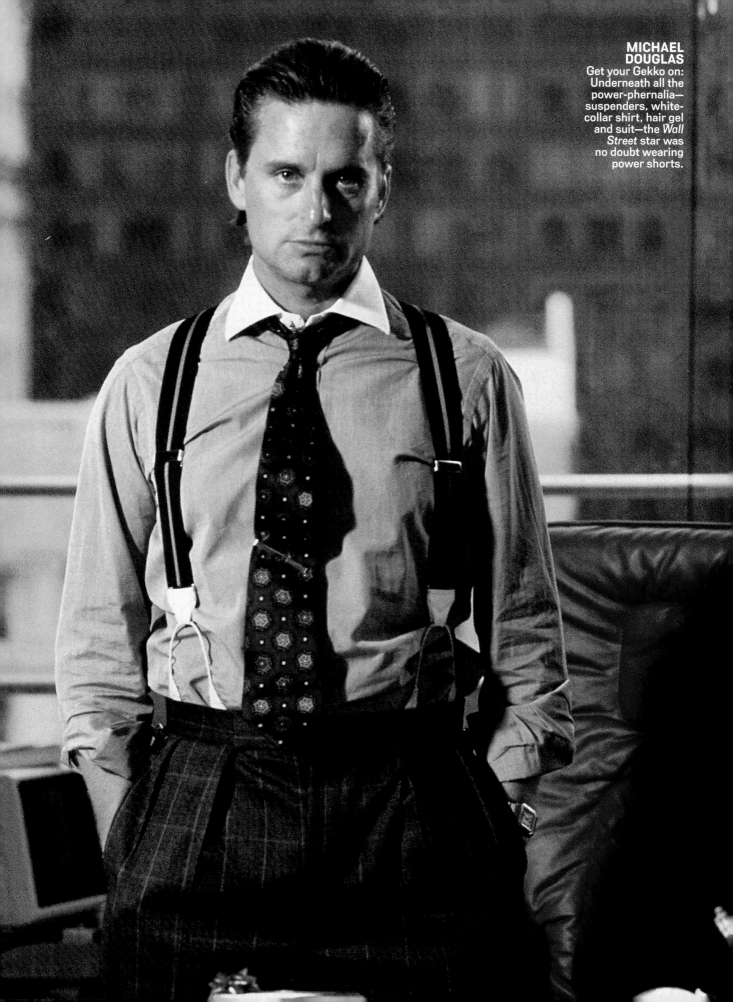

"People keep telling me
I can be a great man.
I'd rather be a good one"

JOHN F. KENNEDY JR.
1988

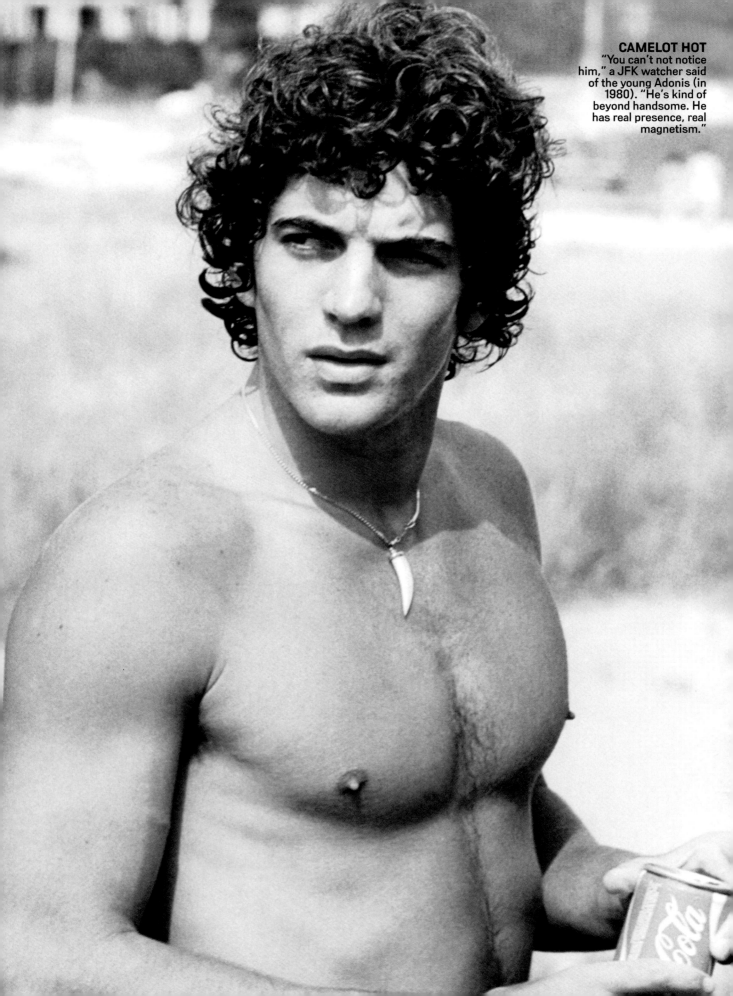

CAMELOT HOT
"You can't not notice him," a JFK watcher said of the young Adonis (in 1980). "He's kind of beyond handsome. He has real presence, real magnetism."

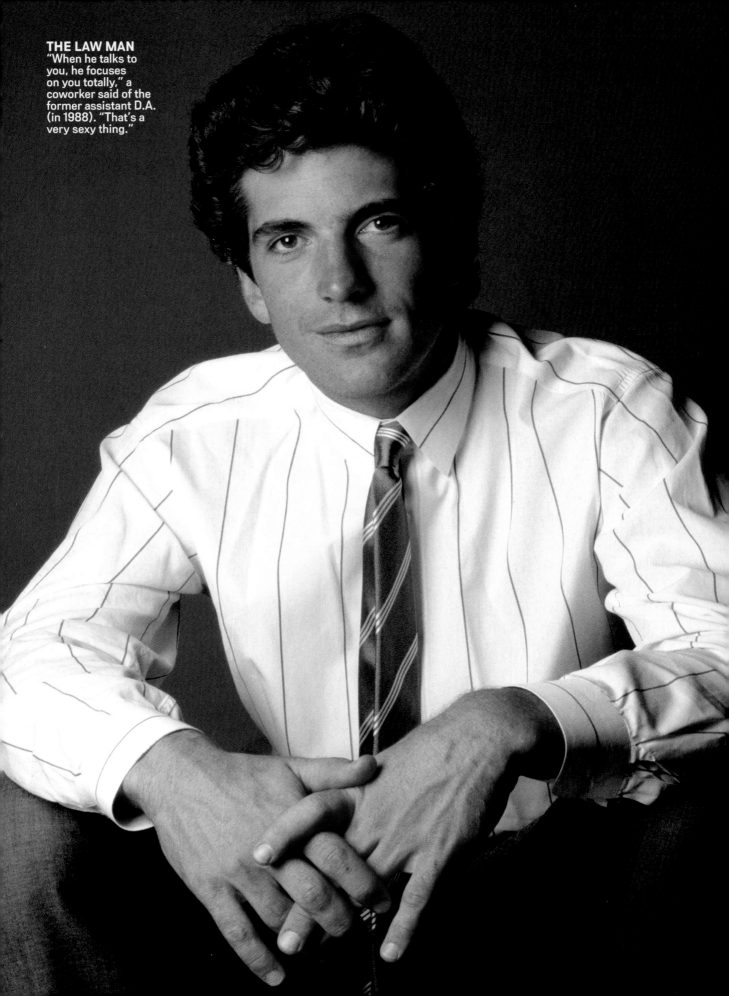

THE LAW MAN
"When he talks to you, he focuses on you totally," a coworker said of the former assistant D.A. (in 1988). "That's a very sexy thing."

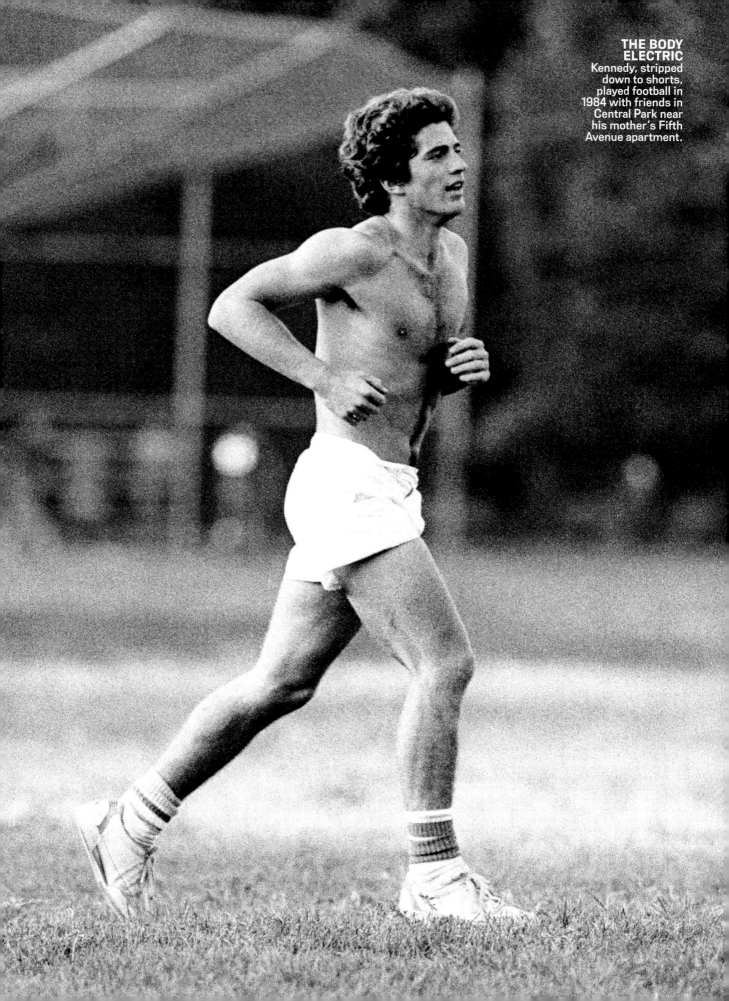

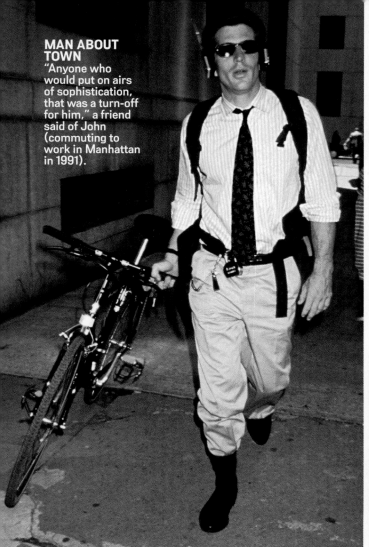

MAN ABOUT TOWN
"Anyone who would put on airs of sophistication, that was a turn-off for him," a friend said of John (commuting to work in Manhattan in 1991).

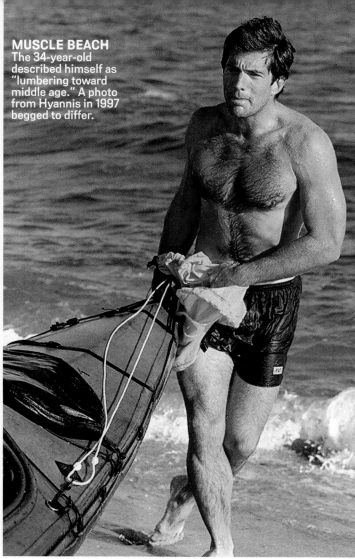

MUSCLE BEACH
The 34-year-old described himself as "lumbering toward middle age." A photo from Hyannis in 1997 begged to differ.

"JFK Jr. is better looking than the movie stars of today"
—EILEEN FORD

GENETICALLY HE ALWAYS HAD A shot at the title. His father was probably history's sexiest U.S. President. His mother was an elegant style icon for 40 years. John F. Kennedy Jr. had her grace, mixed with a love of physical action, especially if it offered a little "manageable danger," as he put it. Six-foot-one, a lawyer and ripped, he was a sort of he-man of the people—and the only nonactor ever named Sexiest Man.

Kennedy had actually toyed with showbiz at Brown University. Cousin Bobby called him a "stupendous actor—really funny." But his mother, Jackie, cautioned, "You can either be or you can act." So JFK Jr. went to law school and famously struggled to pass the bar. ("The Hunk Flunks," screamed the *New York Post*.) Kennedy made no excuses, only a determined promise to keep taking the exam—"until I'm 95" if necessary. It wasn't. He made it on the third try and impressed his boss in the office of the Manhattan D.A., who called him "a hard worker and a great kid." He gave a hint of his political potential when he introduced his uncle Ted at the 1988 Democratic

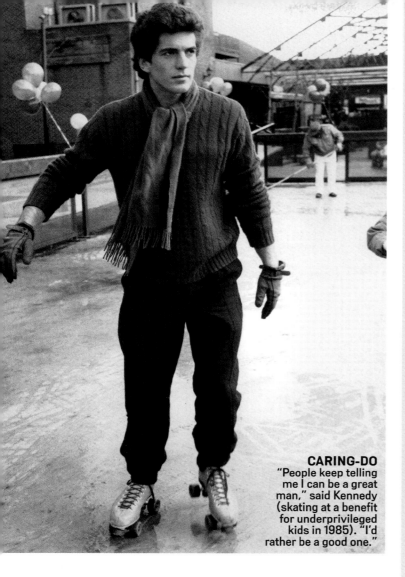

CARING-DO
"People keep telling me I can be a great man," said Kennedy (skating at a benefit for underprivileged kids in 1985). "I'd rather be a good one."

THE JFK JR. EFFECT

"John Kennedy's going to be in my class?! Yeah. Butt. *Butt*. Great butt! John-John's butt"
—JULIA LOUIS-DREYFUS, IN A FAMOUS *SEINFELD* EPISODE

"He used to walk to the post office every day, just after he'd taken a shower. He'd wear just a towel wrapped around his waist and no shirt. . . . He wears the towel practically around his ankles. We've never been able to figure out if he's wearing a bathing suit. He's got an extremely good body"
—A HYANNIS PORT, MASS., NEIGHBOR

"The thickest head of hair I've ever seen" and "perfectly distributed" chest hair
—ONETIME STEADY SARAH JESSICA PARKER

"Several old ladies buying lox started screaming, 'John! John!' It was like the Beatles. A cheese display went flying and a cop said, 'It's a lox riot!' People wanted a piece of him. It was wild"
—P.R. CONSULTANT KEN SUNSHINE

National Convention—and drew a two-minute standing ovation. "I can't remember a word of the speech," said Republican consultant Richard Viguerie, "but I do remember a good delivery. He is strikingly handsome."

In 1995 he launched a glossy magazine, *George,* about pols and issues of the day. All this time, by popular and paparazzi acclaim, he was the nation's most eligible bachelor. "What a catch," noted a talent agent asked to assess Kennedy's value on the marriage market. "Great face. Great body. Great mother-in-law." But the guy was not keen on being caught, and Kennedy dated a glittering array including Madonna and Sarah Jessica Parker. All were involved before, after or during intermissions in his tempestuous, five-year, on-and-off relationship with actress Daryl Hannah. In 1996 the women of the world gave up the dream when he pulled off a secret island wedding to former Calvin Klein publicist Carolyn Bessette.

Three years later, while flying Carolyn and her sister to a wedding, his Piper Saratoga plunged into the sea off Massachusetts. America mourned a famous, handsome, kind, 38-year-old man who lived in the public consciousness from the day he was born. His sister Caroline would carry on the family causes for which John had quietly crusaded, but this was the end of Camelot. ▐▐

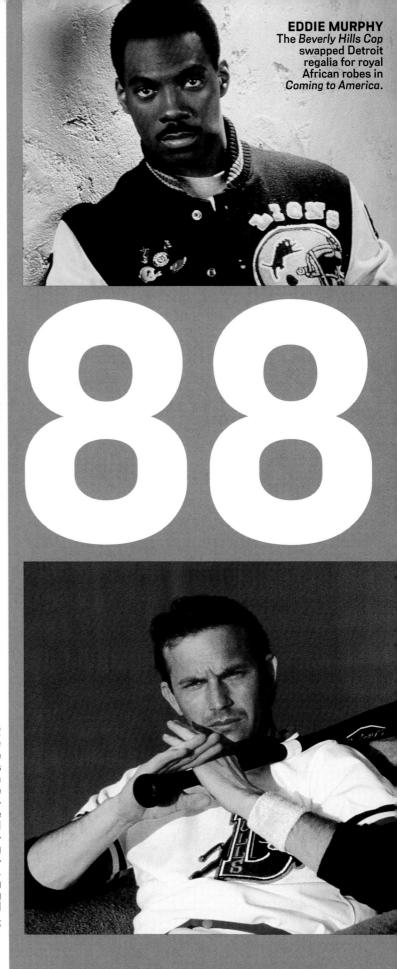

EDDIE MURPHY
The *Beverly Hills Cop* swapped Detroit regalia for royal African robes in *Coming to America*.

WHO WAS SEXY IN
1988

"I believe in long, slow, deep, soft, wet kisses that last three days"

KEVIN COSTNER
For his masterful *Bull Durham* soliloquy: "Well, I believe in the soul . . . the small of a woman's back, the hanging curveball, high fiber, good scotch, that the novels of Susan Sontag are self-indulgent, overrated crap. I believe Lee Harvey Oswald acted alone. I believe there ought to be a constitutional amendment outlawing AstroTurf and the designated hitter. I believe in the sweet spot, soft-core pornography, opening your presents Christmas morning rather than Christmas Eve, and I believe in long, slow, deep, soft, wet kisses that last three days."

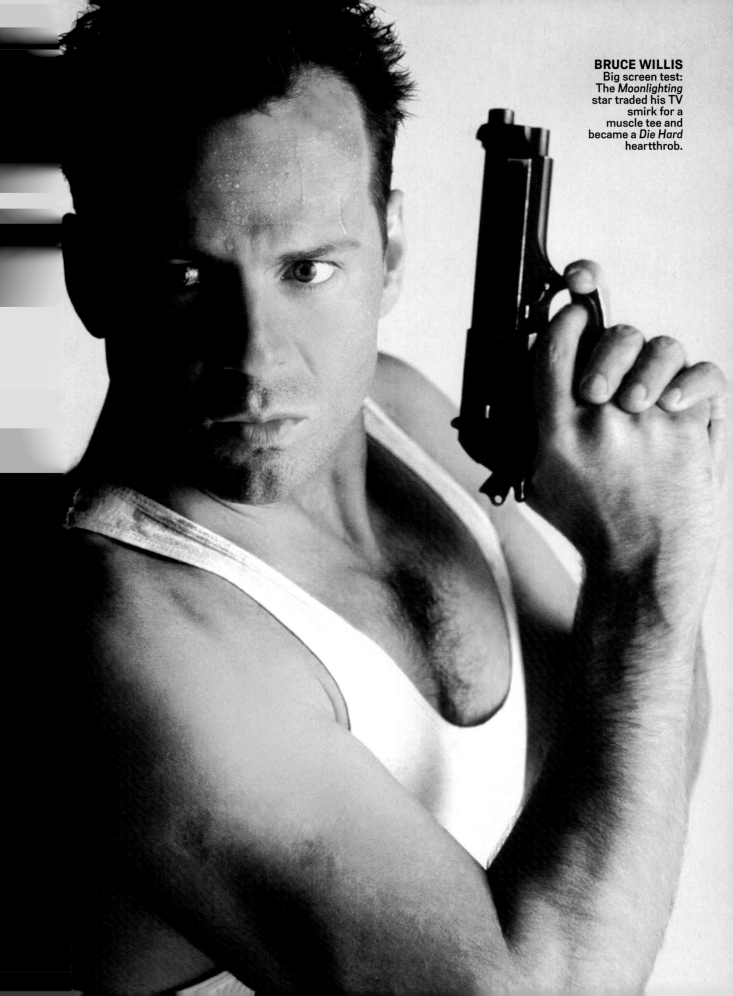

BRUCE WILLIS
Big screen test:
The *Moonlighting*
star traded his TV
smirk for a
muscle tee and
became a *Die Hard*
heartthrob.

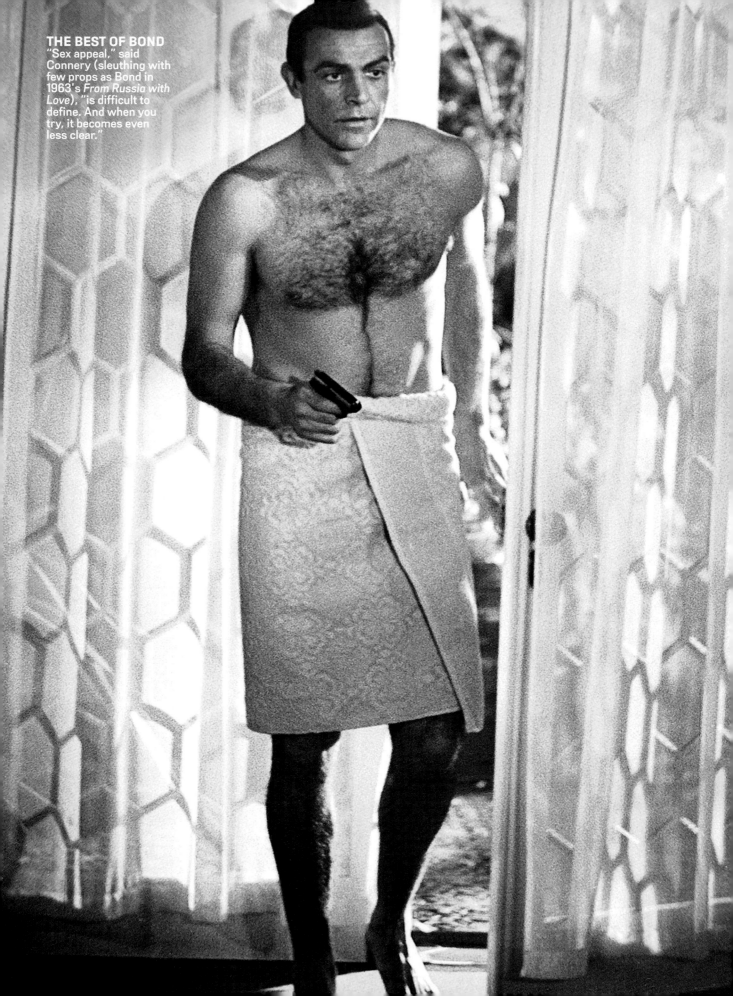

"I would drink Sean Connery's bathwater"

SEAN CONNERY
1989

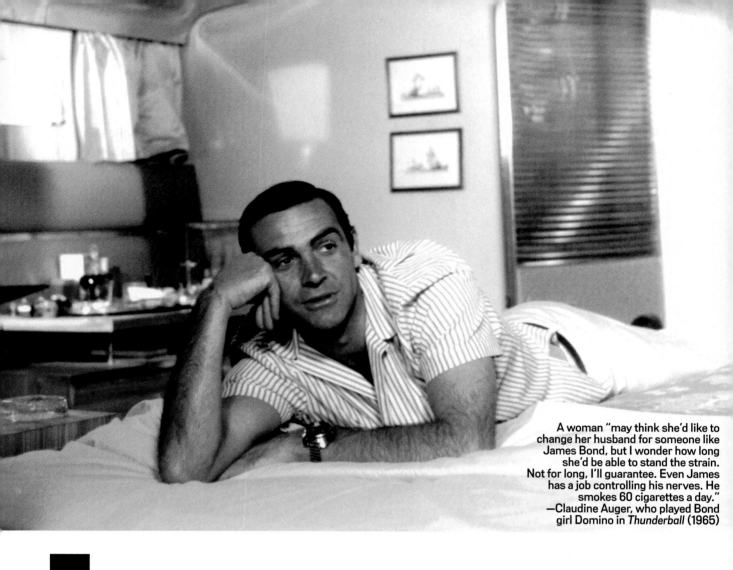

A woman "may think she'd like to change her husband for someone like James Bond, but I wonder how long she'd be able to stand the strain. Not for long, I'll guarantee. Even James has a job controlling his nerves. He smokes 60 cigarettes a day."
—Claudine Auger, who played Bond girl Domino in *Thunderball* (1965)

F SEXIEST MAN ALIVE HAD BEEN around in the 1960s, the Scotsman with the purr-creating burr would be a repeat contender. The words "Bond, James Bond," which he first uttered in 1962's *Dr. No,* turned into a hypnotic incantation. *New Yorker* critic Pauline Kael described him as an equal-opportunity icon: "Women want to meet him and men want to be him." Through seven films Connery wore the role of Ian Fleming's spy like one of his fighting-fit yet wrinkle-free suits.

Unlike the upscale 007, the onetime Edinburgh tenement dweller had a hardscrabble start, delivering milk and polishing coffins. His 6'2" build helped him muscle into a Mr. Universe contest, a touring company of *South Pacific* and repertory work. Cast as the world's first 007—he had a "chewable bottom lip," said Lois Maxwell, who played the recurring character Miss Moneypenny—Connery got the chance to slink undercover with Ursula Andress, Jill St. John and Kim Basinger.

His own romances have been slightly less flashy. Though he dated actress Shelley Winters early in his career, much of his life has been spent in the state of matrimony. His marriage to Australian-born actress Diane Cilento lasted from 1962 to 1973; the couple have one son, actor Jason Connery, and a grandson, Dashiell. Since 1975 he's been wed to French painter Micheline Roquebrune. The two live in the Bahamas.

Onscreen, though, his leading ladies are still feeling the heat. "Sexy? God, yes," said Julia Ormond, who played Guinevere to his King Arthur in 1995's *First Knight,* one of about 15 movies he's made since 1989. "He's totally in command. But he's also very gentle," said Catherine Zeta-Jones, his costar in 1999's *Entrapment.* "On a scale of 1 to 10, he is an 11-plus." And so it was that, at 59, Connery became the oldest person to hold the Sexiest Man title.

In recent years Connery went off-camera to write his memoirs (now scrapped), but he may have ammunition left in his attaché case. There's talk Connery may revisit his *Indiana Jones* role. He also voiced a video-game version of *From Russia with Love.* Even at 75, he doesn't have to worry about his Sexiest Man longevity. Said Barbara Carrera, who appeared in 1983's *Never Say Never Again*: "Sean's a wonderful-looking man. He'll be sexy at 100."

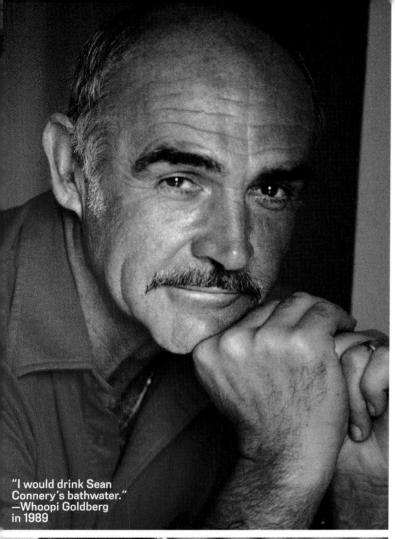

"I would drink Sean Connery's bathwater."
—Whoopi Goldberg in 1989

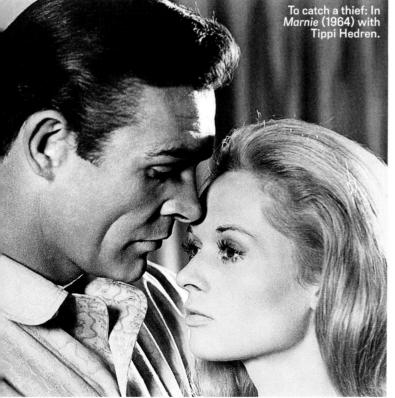

To catch a thief: In *Marnie* (1964) with Tippi Hedren.

MONEYPENNY REMEMBERS

Lois Maxwell played Moneypenny, the loyal secretary to Bond's boss M, in 14 films and flirted regularly with Bond.

On creating a backstory: "I decided that years before . . . they spent a weekend at his Aunt Caroline's cottage in the country, and this coloured their whole relationship."

Moneypenny: You never take me to dinner looking like this, James. You never take me to dinner, period.
Bond: I would, you know. Only I would have been court-martialed for, uh, illegal use of government property.
Moneypenny: Flattery'll get you nowhere—but don't stop trying
—*DR. NO*, 1962

"I loved them all. I always say I would like Roger [Moore] to be my husband and Sean to be my weekend lover"
—LOIS MAXWELL

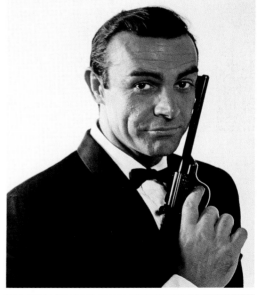

Bond (1968)

WHO WAS SEXY IN
1989

Holy Dreamboats, Batman!

MICHAEL JORDAN Stats, shmats: Bald is beautiful.

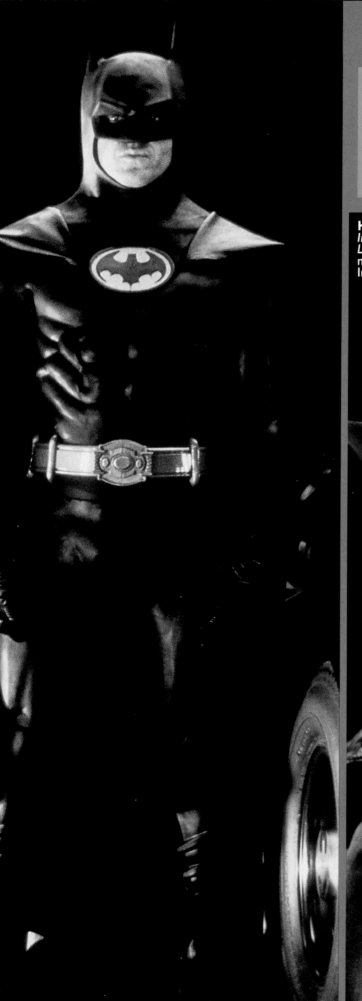

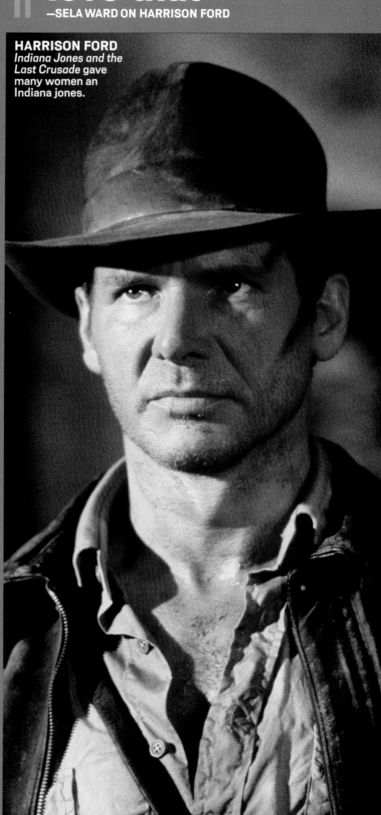

HARRISON FORD
Indiana Jones and the Last Crusade gave many women an Indiana jones.

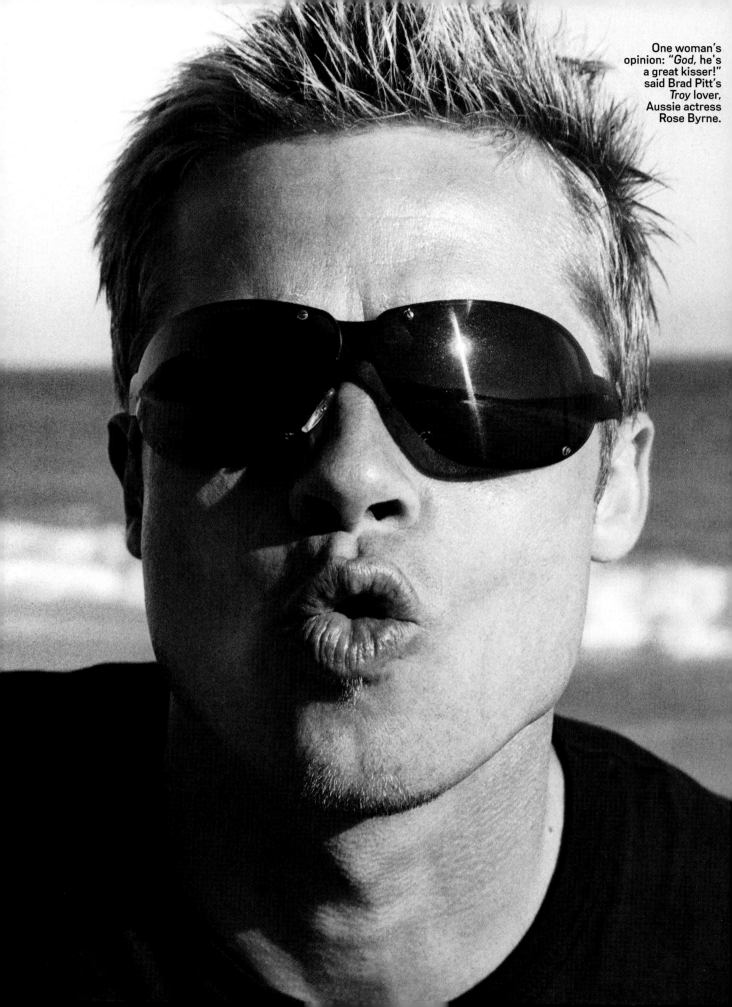

One woman's opinion: *"God,* he's a great kisser!" said Brad Pitt's *Troy* lover, Aussie actress Rose Byrne.

"Clive [Owen] is one of the best kissers"
—ANGELINA JOLIE, COSTAR, *BEYOND BORDERS*, 2003

"My husband would say, 'What are you doing today, honey?' And I'd say, 'Oh, I'm kissing Brad on a bridge.' The next day, 'Oh, I'm kissing Brad in the car.' I bet I'm hated by women around the world"
—CATHERINE ZETA-JONES, COSTAR, *OCEAN'S TWELVE*, 2004

"The best kisser was Harrison Ford, beyond question. He is a great kisser. It was a film called Hanover Street. We started shooting at 8 in the morning and we were in bed for two days"
—LESLEY-ANNE DOWN, COSTAR, *HANOVER STREET*, 1997

"I have to say Sean Penn, who I kissed in U-Turn, was the best"
—JENNIFER LOPEZ, 2002, *COSMOPOLITAN*

"Arnie is a terrific kisser, but he's not as good as my man"
– KELLY PRESTON, ON *TWINS* COSTAR ARNOLD SCHWARZENEGGER VS. BEAU GEORGE CLOONEY, 1989

"It got a little sexy there. Of course he's a good kisser. He knew what he was doing"
—KATHRYN MORRIS, ON BEN AFFLECK, COSTAR, *PAYCHECK*, 2003

"He's a wet kisser"
—HALLE BERRY, ON ADRIEN BRODY'S BEST ACTOR OSCAR WIN KISS, 2003

"Jack is probably a better kisser. He has had more experience than me in that department. He's a very dynamic person, and hard to say no to, I guess. Hopefully, by the time I'm his age, I can catch up to him in acting and all the other delights of life"
—KEANU REEVES, ON JACK NICHOLSON, COSTAR, *SOMETHING'S GOTTA GIVE*, 2004

PUCKER UP, PRETTY BOY!

Lip service? Women who know from experience rate the kissing powers of Sexiest Men and other stars

"I don't trust men who don't dance, don't remember their dreams and don't have lips. [Michael J. Fox] definitely has lips. He's a great kisser. But the best kisser is Raul Julia. As a public service they should put him on a street corner and let everybody kiss him"
— MARGARET WHITTON, COSTAR, *THE SECRET OF MY SUCCESS*, 1987

"So I'm kissing him, and I go to kiss him on the lips, and he passes out! I got ripped off!"
—KAREN ALLEN, COSTAR, ON HARRISON FORD, *RAIDERS OF THE LOST ARK*, 1998

"Jon's very graceful and there's a sweetness about him. He's also a very good kisser"
—BAI LING, ON COSTAR JON BON JOVI, *ROW YOUR BOAT*, 2000

"I just did a movie called Restaurant and the lead guy is Adrien Brody, who everybody will probably know next summer because he is in The Thin Red Line. He was an incredible kisser"
—ELISE NEAL, COSTAR, *RESTAURANT*, 1997

"He has very soulful lips"
—*THAT '70S SHOW* COSTAR MILA KUNIS, ON ASHTON KUTCHER, 2003

"George Clooney. He's a really good kisser. I got to roll around in bed with him, play his wife. I have firsthand experience"
—SELA WARD, COSTAR, *SISTERS*, 1997

"I can report that he's a very good kisser"
—KEIRA KNIGHTLEY, ON *PIRATES OF THE CARIBBEAN* COSTAR ORLANDO BLOOM, 2004

"He's very focused. If he's shaking your hand, he looks you in the eye, and that's the only thing he's doing"

TOM CRUISE 1990

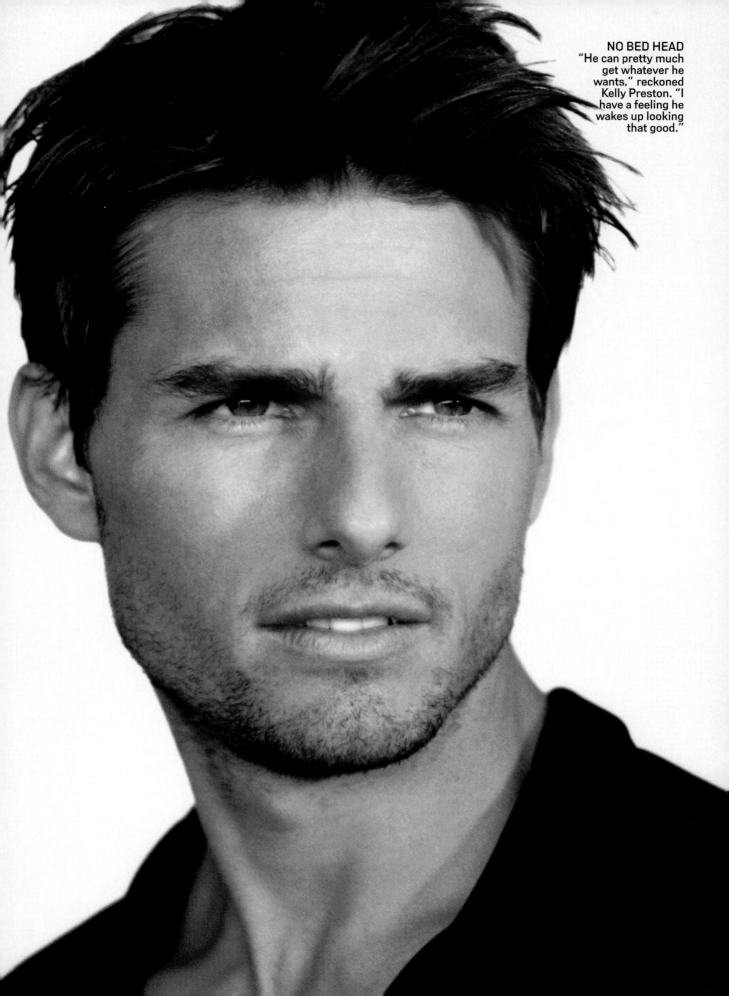

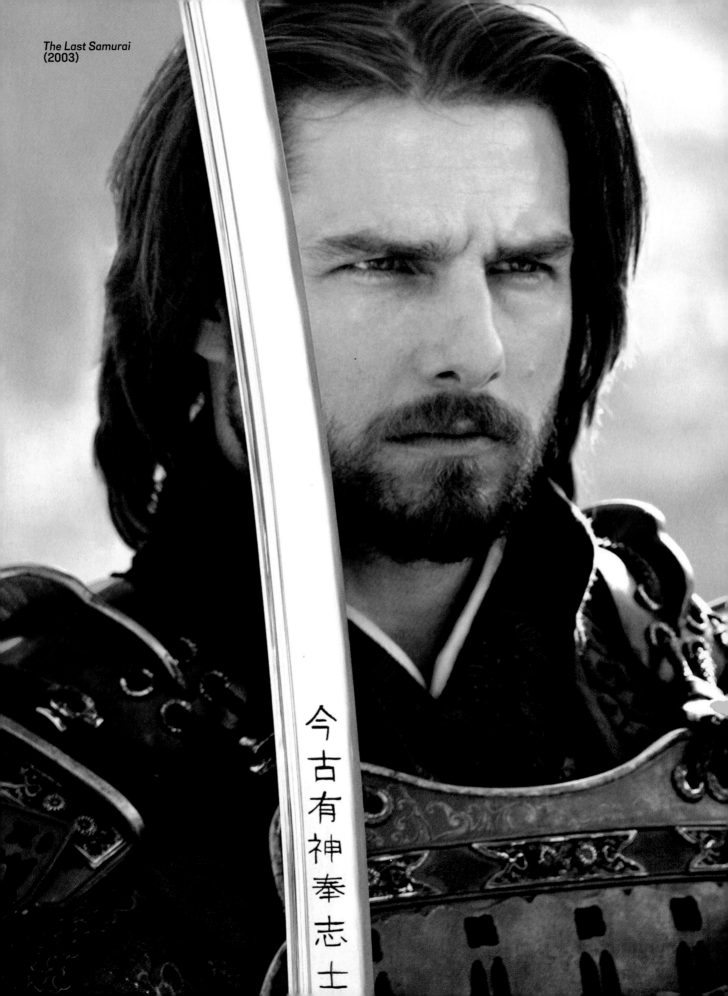

The Last Samurai
(2003)

今古有神奉志士

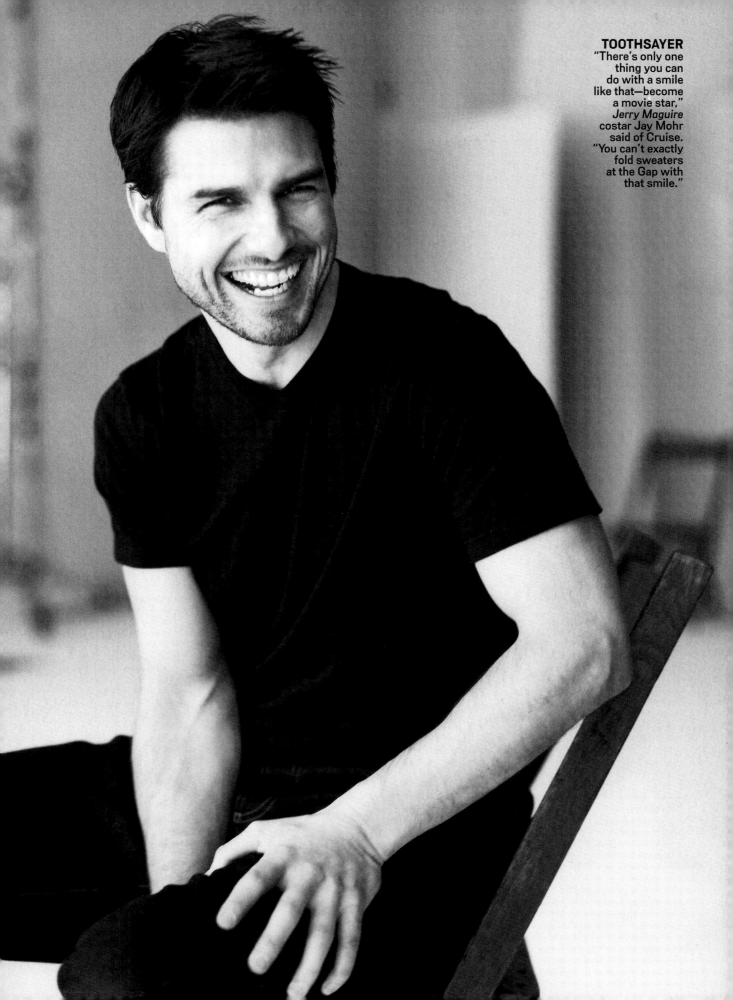

TOOTHSAYER "There's only one thing you can do with a smile like that—become a movie star," *Jerry Maguire* costar Jay Mohr said of Cruise. "You can't exactly fold sweaters at the Gap with that smile."

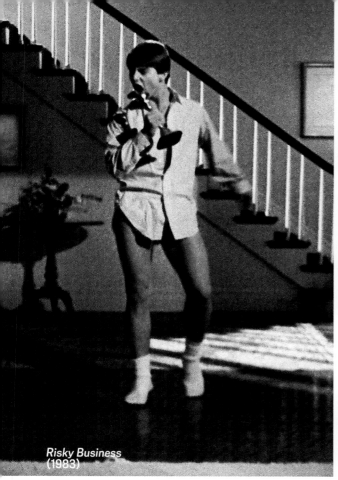

Risky Business
(1983)

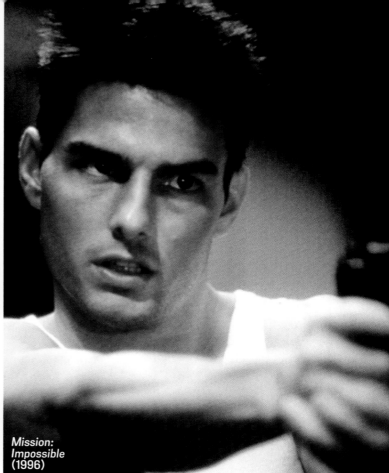

*Mission:
Impossible*
(1996)

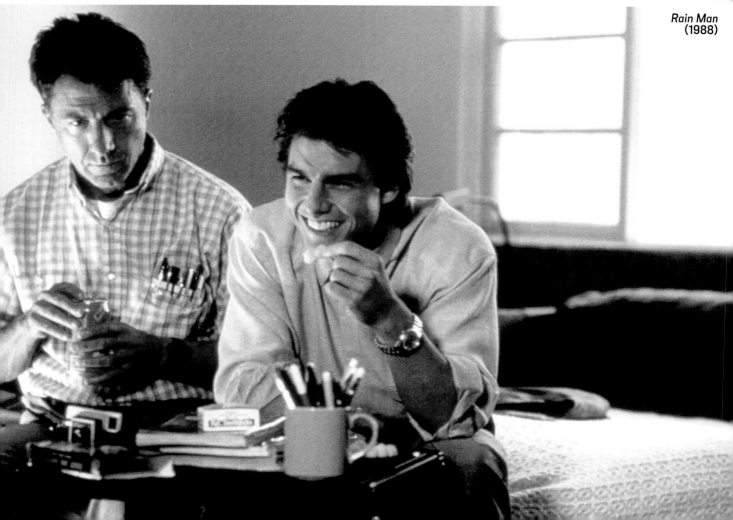

Rain Man
(1988)

PLAYING ANOTHER MAVERICK with a need for speed in *Days of Thunder,* a 28-year-old Tom Cruise—born Thomas Cruise Mapother IV—took the prize as 1990's Sexiest Man Alive. Seven years after he burst on the scene in 1983, rocking out in his underwear in *Risky Business,* Cruise made much of a killer smile and vulnerable sensuality. "And," noted a *Playgirl* editor, "he's muscular in all the right places."

Five months into his reign, Cruise wed his *Days of Thunder* costar Nicole Kidman —in a Christmas Eve ceremony in Telluride, Colo., with his *Rain Man* costar Dustin Hoffman as best man. For Cruise, things would only get sweeter. Plagued by learning disabilities and a father who dropped out of his life at age 11 (they reconciled shortly before Tom Sr.'s death in 1984), he considered joining the priesthood and spent a year in a Franciscan monastery at 14 before changing his mind and setting his sights on Hollywood. By the end of the decade he had won critical acclaim in *Rain Man* and memorable kudos from his costar. "His talent is young, his body is young, his spirit is young," said Hoffman. "He's a Christmas tree—he's lit from head to toe." In the 1990s he became Hollywood's No. 1 box office draw, scoring five straight $100 million-plus flicks, including two *Mission: Impossible* blockbusters. He weathered occasional career misfires, including *Vanilla Sky* and a messy divorce from Kidman, with his genial, clean-cut image mostly intact.

Then came Katie Holmes. Shortly after Cruise, now 43, began dating the 26-year-old actress last spring, cynics suggested the pair were pushing his (*War of the Worlds*) and her (*Batman Begins*) summer movies. In an eyebrow-raising PR blitz, Cruise trumpeted his ardor by leaping on Oprah's couch, then lectured Brooke Shields and Matt Lauer about the dangers of antidepressant drugs and the evils of psychiatry. It was not, certainly, his Sexiest moment. Still, all the hoopla bore financial fruit: With $233 million in box office receipts, *War of the Worlds* was the biggest success of his career—so far. The couple's even bigger news? In October they announced Holmes was pregnant. ▌▌

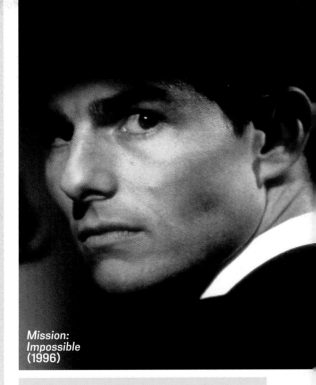

Mission: Impossible (1996)

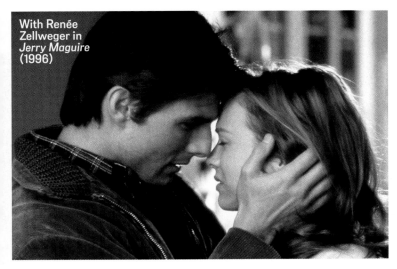

With Renée Zellweger in *Jerry Maguire* (1996)

EYES ON THE PRIZE

"He's very focused. If he's shaking your hand, he looks you in the eye, and that's the only thing he's doing"
—CINEMATOGRAPHER WARD RUSSELL

"Not their color. His regard—the way he looks with them. They're very alive"
—*RAIN MAN* COSTAR VALERIA GOLINO

"You'd look into his eyes, and he'd really be there, he'd really be in love with you. You could see his heart and soul. . . . And then the director would yell, 'Cut!' Tom would leave the set, and you'd have to go into therapy for six months"
—*JERRY MAGUIRE* COSTAR RENÉE ZELLWEGER

WHO WAS SEXY IN 19 90

Pretty Woman's escort was a looker too

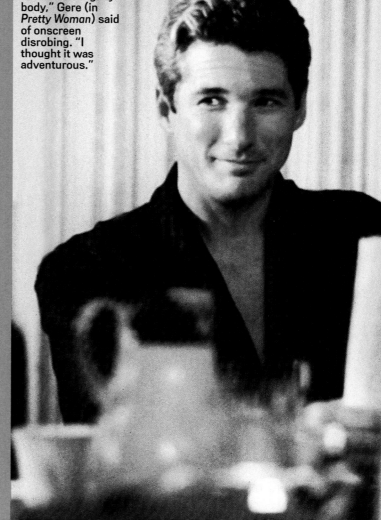

RICHARD GERE
"I had no qualms about showing my body," Gere (in *Pretty Woman*) said of onscreen disrobing. "I thought it was adventurous."

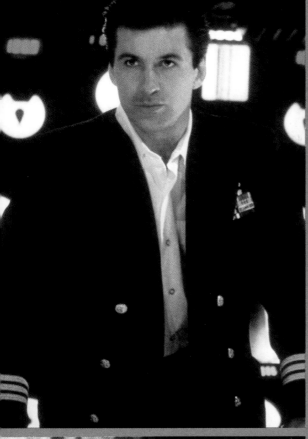

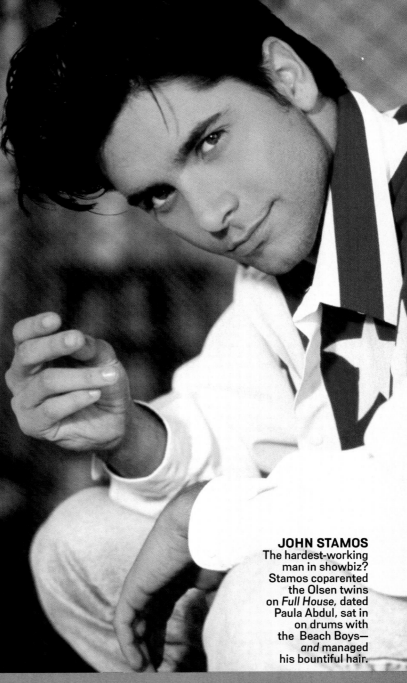

JOHN STAMOS
The hardest-working man in showbiz? Stamos coparented the Olsen twins on *Full House,* dated Paula Abdul, sat in on drums with the Beach Boys— *and* managed his bountiful hair.

"He is dangerous and sexy—all the things I like to see in movies"
—KIM CATTRALL ON RICHARD GERE

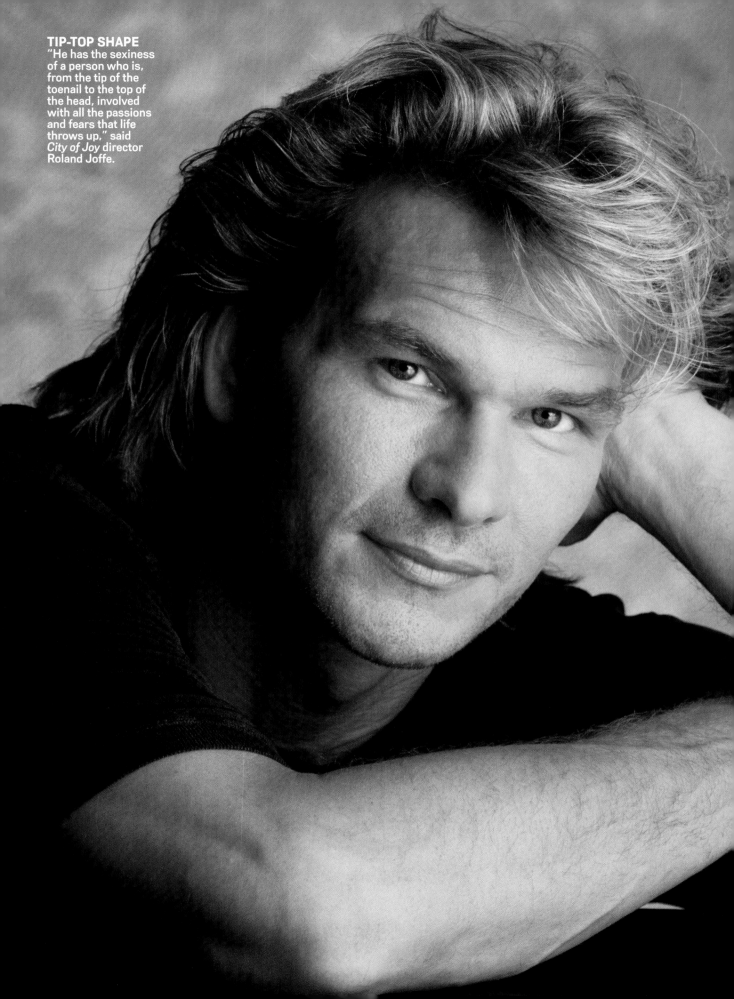

TIP-TOP SHAPE
"He has the sexiness of a person who is, from the tip of the toenail to the top of the head, involved with all the passions and fears that life throws up," said *City of Joy* director Roland Joffe.

"I've always loved putting myself in a position where, if I don't pull something off, I'll die"

PATRICK SWAYZE
1991

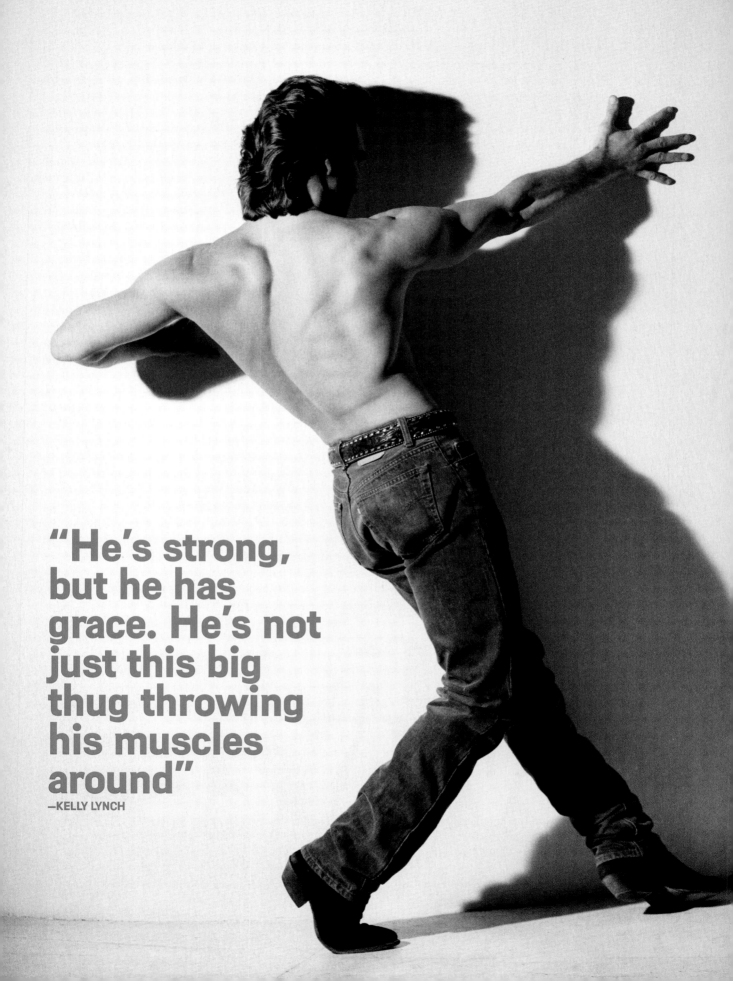

"He's strong, but he has grace. He's not just this big thug throwing his muscles around"
—KELLY LYNCH

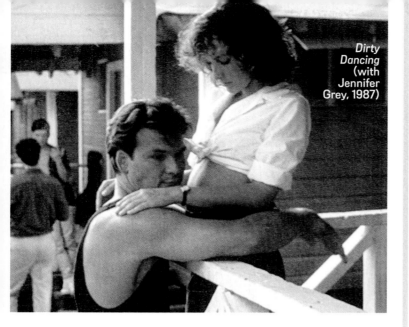

Dirty Dancing (with Jennifer Grey, 1987)

WHETHER CALLED UPON TO rope a calf, swan-dive into a pool, jump from an airplane or cry on cue, Patrick Swayze performed such feats with the same grace that he brought to one of his peerless pirouettes. But when it came to sex on the set, he blushed. "Love scenes are the scariest thing I do," he confessed. "You have to hook into some powerful passion [and] your feelings for the woman that's really in your life. If the passion isn't there, it just looks like two people sucking face."

Swayze was riding a tidal wave of popularity when he won his metaphorical crown in 1991. He set the stage with the megahit *Dirty Dancing* in 1987, a Cinderella-in-the-Catskills love story costarring Jennifer Grey. Its appeal, Swayze says today, was "this funky little Jewish girl getting the guy because of what she [has] in her heart." Then, in 1990, came the full-gush romance *Ghost,* in which he and Demi Moore seemed to transform a potter's wheel into a piece of erotic equipment. With sales for *Ghost* and *Dancing* totaling $400 million, the Texas-bred actor established himself as a bona fide box office hit and a hunk with a softer side. Patrick "has a sweet, gentle and kind heart," said Moore. "And those Southern manners!"

The formally trained ballet dancer is also a risk taker—performing his own stunts as a bank-robbing, skydiving surfer opposite Keanu Reeves in 1991's cult favorite *Point Break.* "I've always loved putting myself in a position where, if I don't pull something off, I'll die," Swayze told PEOPLE. Now 53, he recently finished a labor of love, *One Last Dance.* The drama, set in the world of professional dancers, costars his wife of 30 years, actress-dancer Lisa Niemi, who's also the director. (The two met when Niemi, now 49, was just 15 and a student of Swayze's choreographer mom, Patsy.) But Swayze is still willing to keep fans guessing: In his next project, *Keeping Mum,* a "trippy dark English comedy," opposite Dame Maggie Smith, Rowan Atkinson and Kristin Scott Thomas, he gets to play a "horny golf pro." Twenty years later, nobody puts Swayze in a corner. ∎

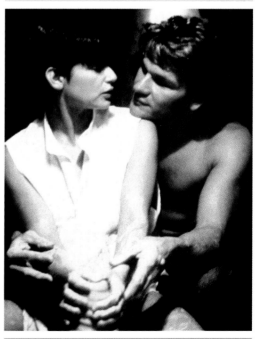

Ghost (1990)

WHO WAS SEXY IN

1991

Lickety Zip . . .
from Sherwood
Forest to
Beverly Hills

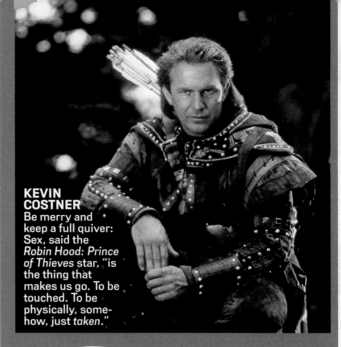

KEVIN COSTNER
Be merry and keep a full quiver: Sex, said the *Robin Hood: Prince of Thieves* star, "is the thing that makes us go. To be touched. To be physically, some-how, just *taken*."

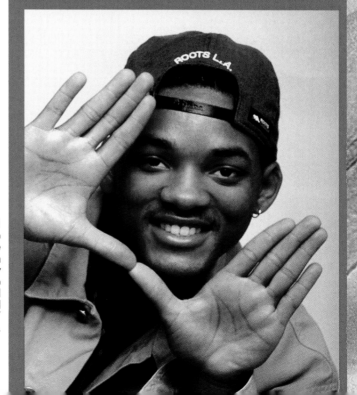

WILL SMITH
The rapper made the hop to TV's *The Fresh Prince of Bel-Air.* "This is a character who is *definitely* having sex. He needs to explore those issues, and me as an artist, I need to explore those issues," Smith joked.

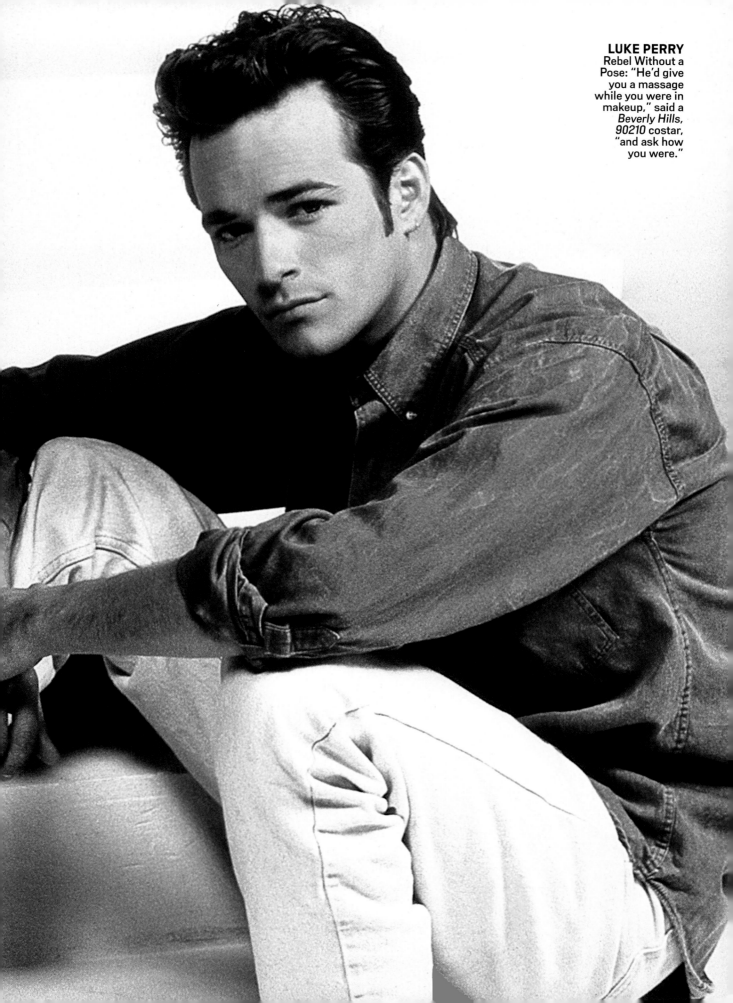

NICK NOLTE
1992

"He's attractive in a strong, sexy, hunky sort of way"

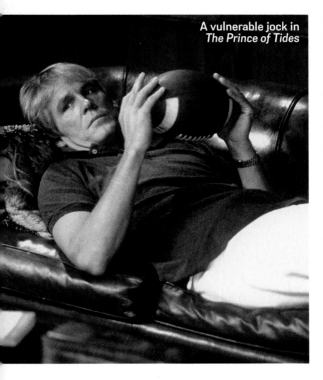

A vulnerable jock in *The Prince of Tides*

LONG BEFORE A FAMOUSLY UNFLATTERING MUG SHOT OF THE disheveled and bleary-eyed actor made the rounds in 2002, Nick Nolte displayed a framed copy of his Sexiest Man cover in his office—for laughs. "When people mention it," a pal once said, "he's likely to thrust out his gut and say, 'Is *this* sexy?'" Back then—with the belly pulled *in*—it was. Nolte—then 51 but with surfer-boyish looks, a manly swagger and wounded-soul eyes—thrummed the hearts of females of all ages, including then-21-year-old Shannen Doherty. "He's attractive," she said, "in a strong, sexy, hunky sort of way." A late-blooming actor, Nolte was 35 when he debuted—playing a 17-year-old—in the hit 1976 miniseries *Rich Man, Poor Man.* But he became almost better known for his struggles to stay on the wagon than for the big-screen vehicles—*North Dallas Forty, 48 Hrs., Down and Out in Beverly Hills*—that brought him stardom. "It was hard to see the real Nick then," his *Under Fire* costar Joanna Cassidy said after Nolte cleaned up in the late '80s. "But he's allowed a lot of compassion to emerge now. And as a man, that makes him very sexy." Hits (*Affliction*) and missteps (*I'll Do Anything*) followed—as well as continuing struggles to curb his appetites. Now 64 and sober since undergoing court-ordered rehab, Nolte—thrice divorced, single and living in Malibu—has completed an aptly titled film, *Clean.*

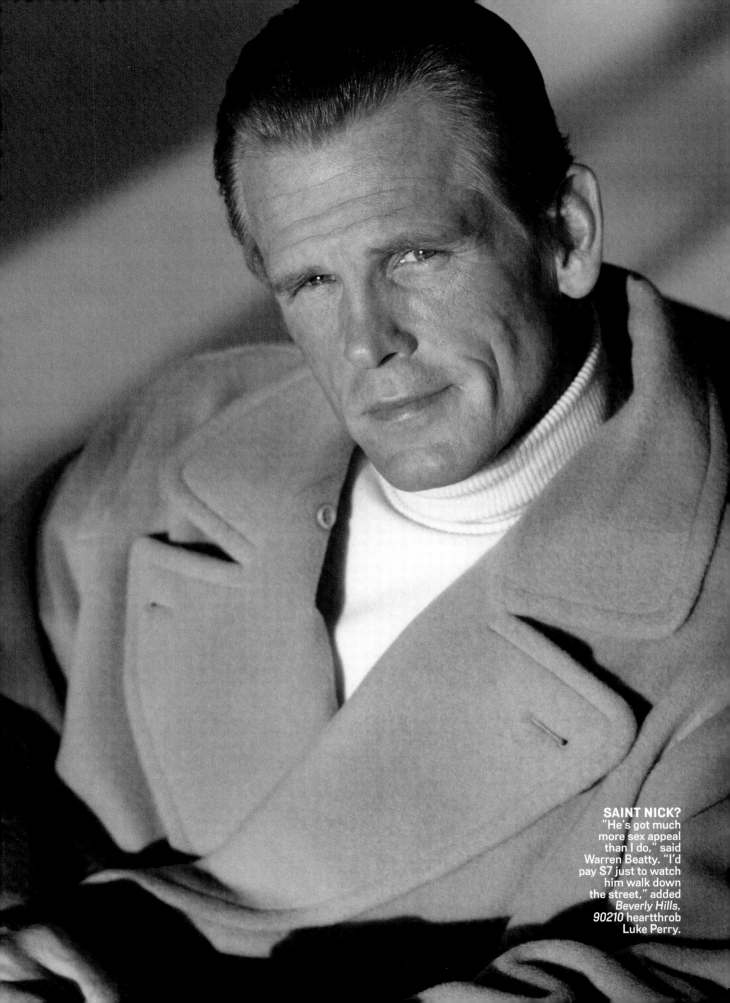

SAINT NICK?
"He's got much more sex appeal than I do," said Warren Beatty. "I'd pay S7 just to watch him walk down the street," added *Beverly Hills, 90210* heartthrob Luke Perry.

MARCUS
SCHENKENBERG
The jeans and underwear
model became the latest
in Calvin Klein's long line
of abdominal showmen.

WHO WAS
SEXY IN
19

92

Get me a pair
of Calvin Kleins
and a six-pack.
On second
thought, do you
have anything in a
nice buckskin?

ANDREW SHUE
Everybody into the
pool: Viewers tuned
in for *Melrose
Place*'s buff Billy.

DANIEL DAY-LEWIS
The *Last of the Mohicans* star won hearts by pledging his love to costar Madeleine Stowe— "Just stay alive, no matter what occurs! I *will* find you!"—but, curiously, his outfit failed to inspire designer knockoffs.

"I've heard women even find the back of his neck sexy"

—PHILIP KAUFMAN, DIRECTOR,
THE UNBEARABLE LIGHTNESS OF BEING

1993
RICHARD GERE
CINDY CRAWFORD

For one shining moment, they walked the earth as the first— and, so far, only— Sexiest Couple Alive

SEPARATELY THEY WERE ASTONISHING. HE HAD ROARED BACK AS A superstar a few years earlier. She was a supermodel at the peak of her powers. Together they caused more than a smidge of envy.

With his sexually frank performance in 1980's *American Gigolo,* Gere had become a new generation's sex symbol. After losing rank following several box office blunders, the actor returned triumphant with the 1990 Cinderella story *Pretty Woman.* In the meantime, Crawford had become a household name, her face, beauty mark and voluptuous figure gracing 300-plus magazine covers, must-see soft-drink commercials and a weekly hit, MTV's *House of Style.* The impossibly glamorous pair began dating in 1988 and, three years later, flew to Las Vegas, where they exchanged vows and aluminum-foil wedding bands at the Little Church of the West. "It is the most disappointing thing I have ever seen," joked Gere pal and *Pretty Woman* producer Arnon Milchan in our cover story. "I hate it. They really *are* in love."

For four years, yes. But in 1995 they divorced. Crawford said later of the amicable split, "It was like saying goodbye to that [idea] I had that life was going to be perfect." Not to worry. Each later found their current spouses: Crawford wed her old flame, model-turned-club-owner Rande Gerber, in 1998; Gere met ex-Bond girl and future *Law & Order* prosecutor babe Carey Lowell in 1995; they married in 2002. And a few years later Gere was named Sexiest—solo.

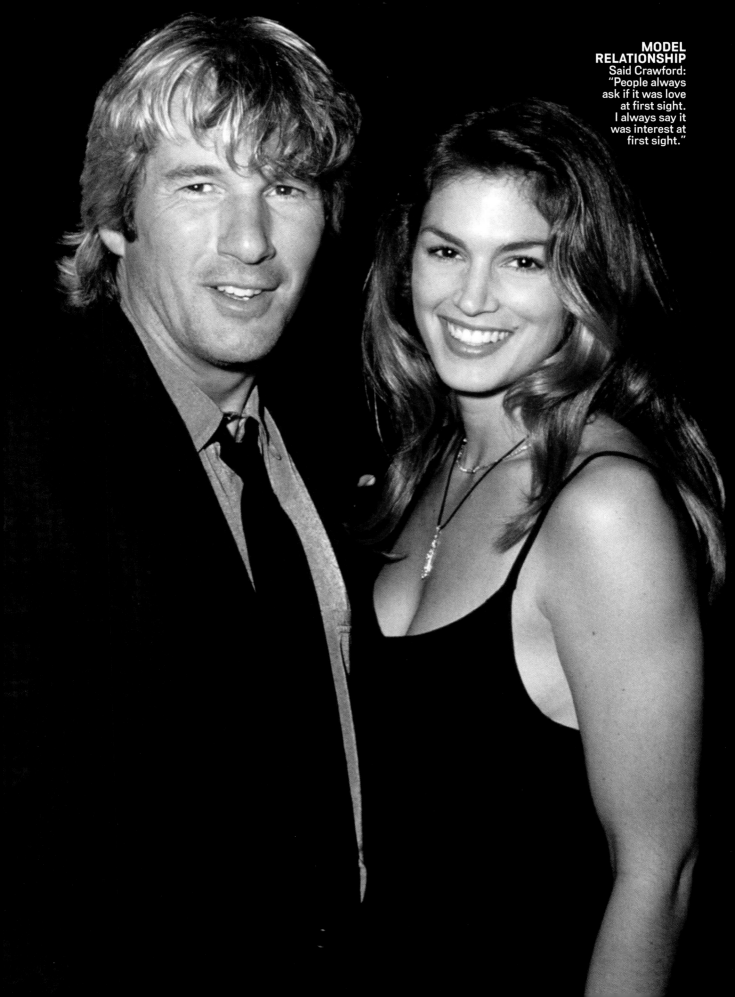

MODEL RELATIONSHIP
Said Crawford: "People always ask if it was love at first sight. I always say it was interest at first sight."

WHO WAS SEXY IN 19 93

Hanks on the line from Seattle; Cain in a Super suit

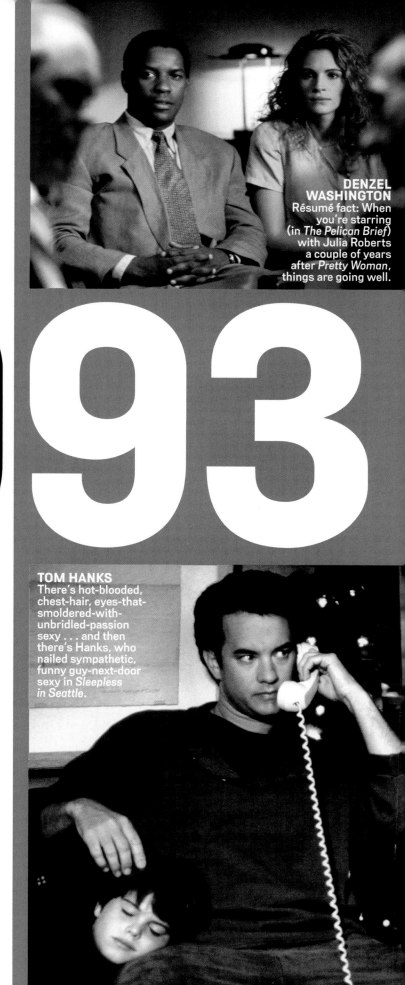

DENZEL WASHINGTON
Résumé fact: When you're starring (in *The Pelican Brief*) with Julia Roberts a couple of years after *Pretty Woman*, things are going well.

TOM HANKS
There's hot-blooded, chest-hair, eyes-that-smoldered-with-unbridled-passion sexy . . . and then there's Hanks, who nailed sympathetic, funny guy-next-door sexy in *Sleepless in Seattle*.

Oddly, there was no Sexiest Man in 1994. Not because no one was sexy. And certainly not because there was no 1994. (We have a stub from an Ace of Base concert to prove it.) Truth? We were a little coy, and didn't commit to making it an annual until 1997

WHO SHOULD HAVE BEEN SEXIEST?

1994

KEANU REEVES Back in his high school days in Toronto, he was "almost gangly—tall and thin, with long hair over his eyes," recalled Reeves' hockey coach. As a callow youth best known for *Bill & Ted's Excellent Adventure*, he once appeared on a film set dressed in combat boots and a skirt. "It's comfortable," he said. So it was a new look for the Keanu who appeared in 1994's *Speed*. "I didn't want to be cut," he said, for his role as an LAPD cop on a bomb-rigged bus who rises to the harrowing occasion. "But I wanted to have somewhat of a beefy aspect to my chest and arms."

JOHN TRAVOLTA On his dance floor turn with Uma Thurman in *Pulp Fiction*: "I'm a man with a gut and it still gets the audience to go 'Whooo, he's dancing!' At least I didn't have to wear white polyester."

HUGH GRANT The dandy-locked *Four Weddings and a Funeral* newcomer charmed with heroic, stuttery self-deprecation. "I haven't found an American woman yet who hasn't flipped for him," said his director.

GEORGE CLOONEY "I can be a schmuck all day long, at the end of it save some old lady's life," he said of his role as *ER*'s charmer. "If you stuck a mannequin in my part, he'd get all the fan mail."

Let us now praise famous (really good-looking) men: The guys who set the standard before the Sexiest Man Alive was invented THE CLASSICS

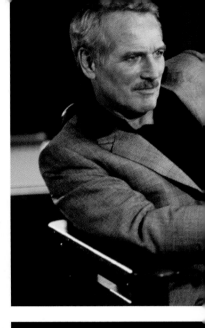

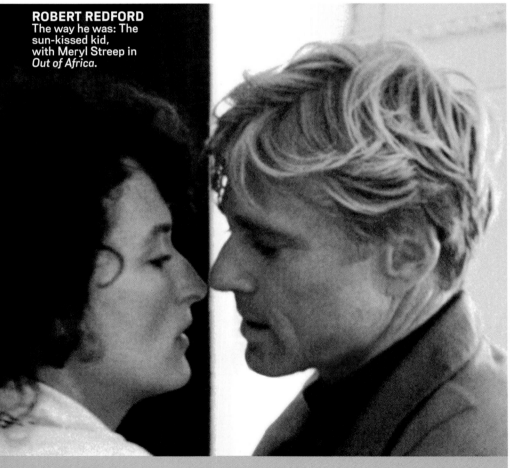

ROBERT REDFORD
The way he was: The sun-kissed kid, with Meryl Streep in *Out of Africa*.

"I thought he was subtle—and just right. But then I'm the worst one to ask. I had a big crush on him. He's the best kisser I ever met in the movies"
MERYL STREEP, COSTAR IN *OUT OF AFRICA*

"I have never known such pleasure. He could handle women as smoothly as operating an elevator"
BRITT EKLAND, IN HER 1980 BOOK *TRUE BRITT*

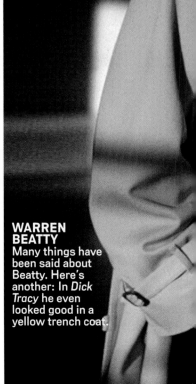

WARREN BEATTY
Many things have been said about Beatty. Here's another: In *Dick Tracy* he even looked good in a yellow trench coat.

PAUL NEWMAN
Women have been singing praises of Newman's own baby blues for decades.

"You see his eyes no matter what he does. I'm not talking like I have a mad crush, but he's so attractive, *so* attractive, that you just can't help liking him"

MARTHA STEWART, CONNECTICUT NEIGHBOR

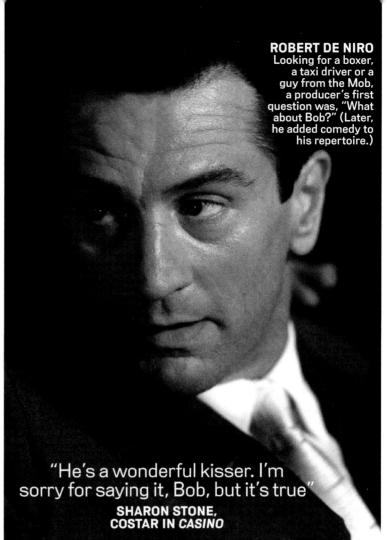

ROBERT DE NIRO
Looking for a boxer, a taxi driver or a guy from the Mob, a producer's first question was, "What about Bob?" (Later, he added comedy to his repertoire.)

"He's a wonderful kisser. I'm sorry for saying it, Bob, but it's true"

SHARON STONE, COSTAR IN *CASINO*

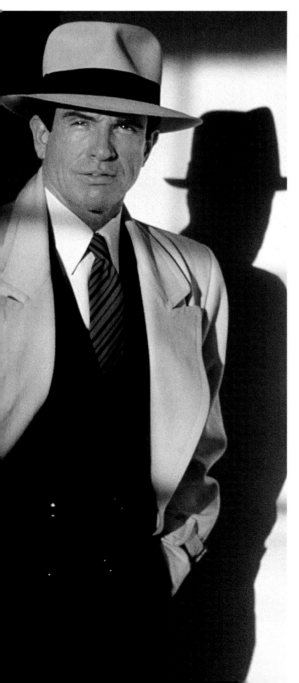

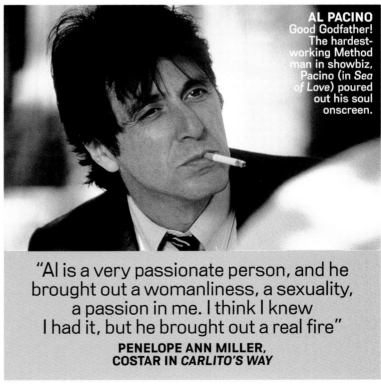

AL PACINO
Good Godfather! The hardest-working Method man in showbiz, Pacino (in *Sea of Love*) poured out his soul onscreen.

"Al is a very passionate person, and he brought out a womanliness, a sexuality, a passion in me. I think I knew I had it, but he brought out a real fire"

PENELOPE ANN MILLER, COSTAR IN *CARLITO'S WAY*

"He was so good-looking and charismatic . . . everybody knew he was going places"

BRAD PITT
1995

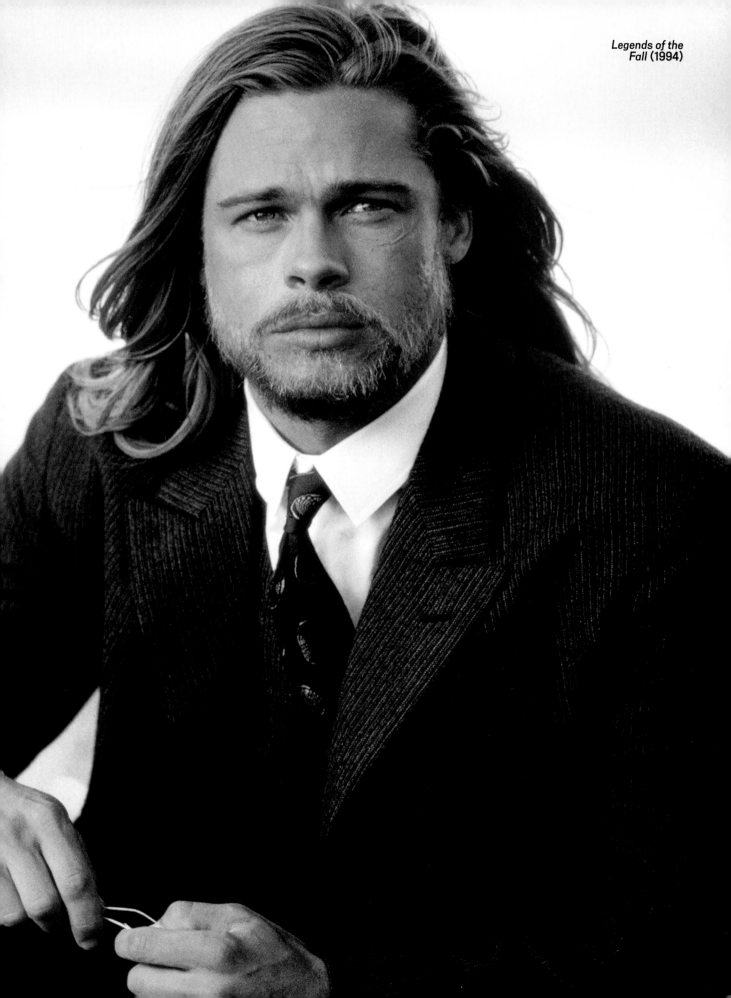

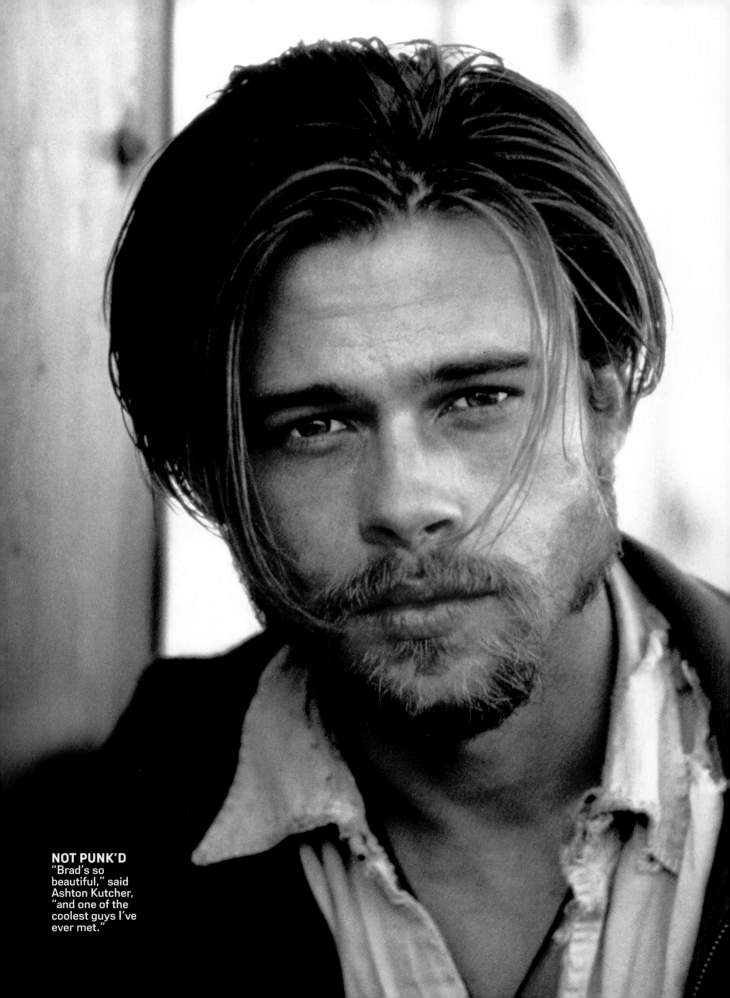

NOT PUNK'D
"Brad's so
beautiful," said
Ashton Kutcher,
"and one of the
coolest guys I've
ever met."

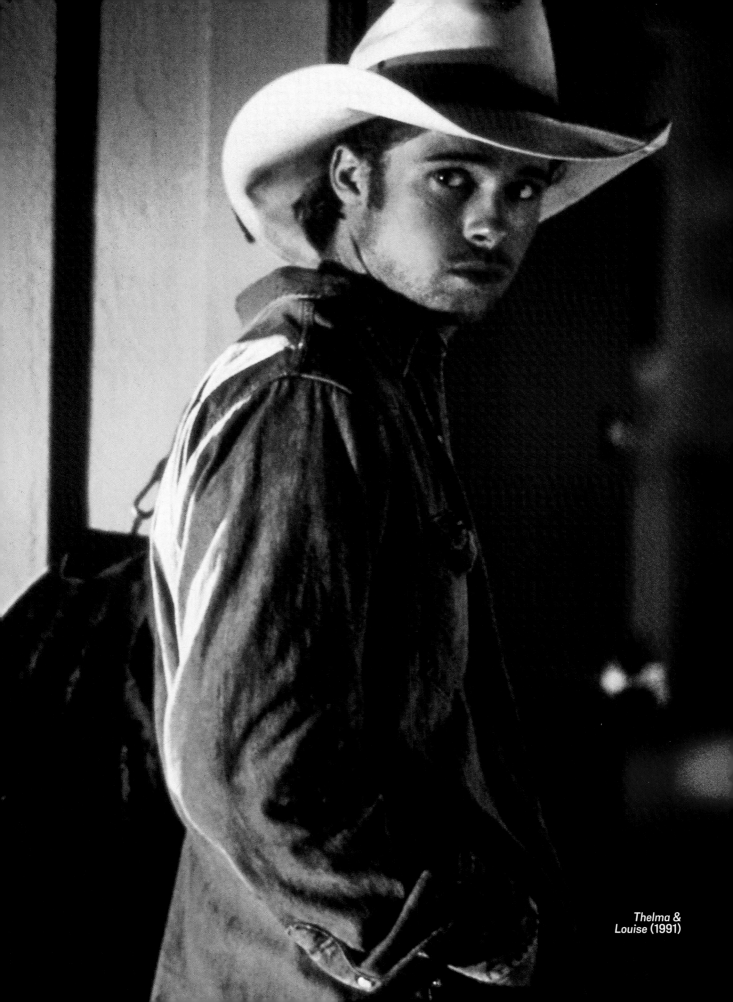

*Thelma &
Louise* (1991)

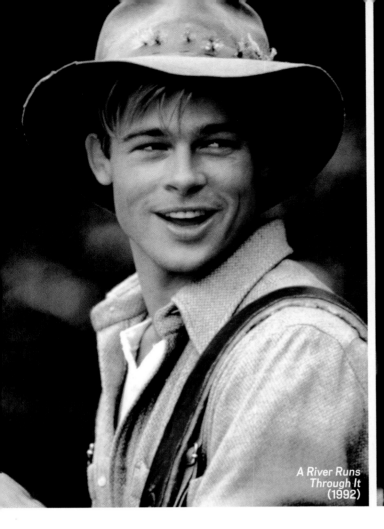

A River Runs Through It (1992)

TOM HANKS WAS CRUISING IN *Apollo 13*. Pierce Brosnan had stepped into 007's shoes for *GoldenEye*. Bruce Willis was advertising his *Die Hard*-body. But in 1995 nobody bested Brad, whose tools of seduction were man's simplest: dimples, blue eyes, that smile, those abs—that sort of thing.

The very first gander—when he stripped down in 1991's *Thelma & Louise* and took Geena Davis's breath (and money) away—was prologue. In 1992's *A River Runs Through It,* fly fishing never looked so good. By 1994, volunteers would have lined up to have their necks bitten by Brad's beautiful bloodsucker in *Interview with the Vampire*. That glam-Goth flick was still in theaters in '95, when Brad, quite unfairly for others who would be Sexiest, donned leather chaps and rode stallions in *Legends of the Fall*. Pitt's allure as a cop in 1995's gruesomely quirky thriller *Seven*, an indy release that seemed destined for cult interest only, helped the film tally $100 million. Women liked the guy. "When he looked at me," said a rattled waitress, "I was worried [I'd] drop his chicken and lemonade in his lap."

That sort of thing had been a constant almost since the Oklahoma native's days as a choirboy in Springfield, Mo. "You couldn't [stop] watching Brad because his face was so expressive,"

"He's a classic American lover," said a *Seven* crew member. "He's a man women can love and like at the same time"

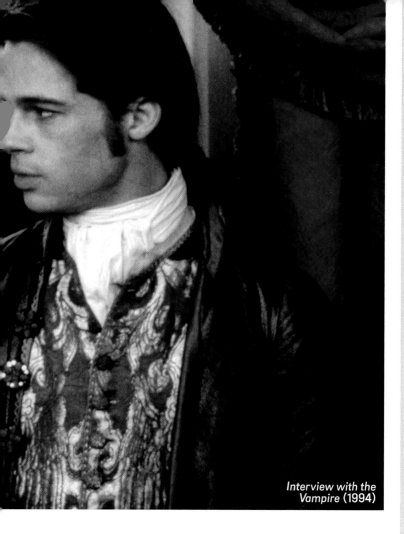

Interview with the Vampire (1994)

PITT'S MAGIC MOMENT? A SCENE IN 1991'S *THELMA & LOUISE* WHERE, AS A CHARMING STICKUP ARTIST, HE EXPLAINS THE FINE POINTS OF ARMED ROBBERY. OVERNIGHT, HIS SHOWBIZ STATUS WENT FROM "BRAD WHO?" TO "GET ME BRAD PITT!"

J.D.: [*shirtless, and using a hair-drier as a prop gun*]: I kinda waltz right in and say, "Ladies, gentlemen, let's see who wins the prize for keeping their cool. Simon says: Everybody down on the floor! Now, nobody loses their head, nobody loses their head. Ah, you, sir. Yeah. You do the honors. Take that cash and put it in that bag right there and you got an amazing story to tell your friends. If not, then you got a tag on your toe. You decide." Simple as that. Then I just slip on out and get the hell outta Dodge. Yeah.

THELMA: My goodness. You're sure gentlemanly about it.

J.D.: Well, I've always believed that done properly, armed robbery doesn't have to be a totally unpleasant experience.

THELMA: You're a real live outlaw, aren't ya?

J.D.: I may be an outlaw, darlin', but you're the one stealin' my heart.

recalled the pianist at the South Haven Baptist Church, where Pitt and his family—a trucking company exec, his school counselor wife and Pitt's younger brother and sister—were Sunday regulars. "He attracted everyone's attention."

That was pretty much his m.o. at Springfield's Kickapoo High School and the University of Missouri, where he studied journalism, posed shirtless for a campus calendar and dropped out two credits shy of graduation. After stints hawking fast food in an El Pollo Loco chicken suit and chauffeuring strippers in a limousine, he landed guest parts in TV shows like *Dallas* and *Head of the Class*. The latter's leading lady, Robin Givens, risked ex-hubby Mike Tyson's wrath to date Pitt for three months.

Costars, it seemed, were as taken as the next girl by Brad, who shared a home and billing with *Kalifornia*'s Juliette Lewis, just 16 when they met on the set of a 1990 TV movie, *Too Young to Die?* Geena Davis dated Brad after the cinematic bedding that made him a Hollywood hottie. "He caused such a stir on the set," said *thirtysomething* producer Marshall Herskovitz of a brief one-line Pitt stop on the series in 1989. "He was so good-looking and charismatic and such a sweet guy, everybody knew he was going places." Quite so, but no soothsayer could have predicted where Brad was bound: For a rare second tenure as PEOPLE's Sexiest Man, a storybook wedding to *Friends* sweetheart Jennifer Aniston—and, of course, all the dizzying headlines that followed.

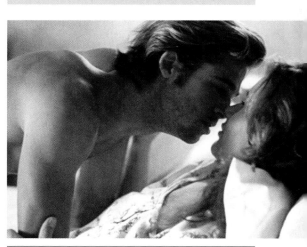

Thelma & Louise (1991)

WHO WAS SEXY IN

1995

**MATT LEBLANC
DAVID SCHWIMMER
MATTHEW PERRY**
On *Friends*, somehow even funny became sexy.

JARED LETO
He made Claire Danes's teen years even angstier on *My So Called Life*. "Those eyes have a magnetic effect on women," she said.

Fresh from out of town, Antonio Banderas was—to quote *Saturday Night Live*—"How you say … sexy?" And Jimmy Smits gave trench coats a good name

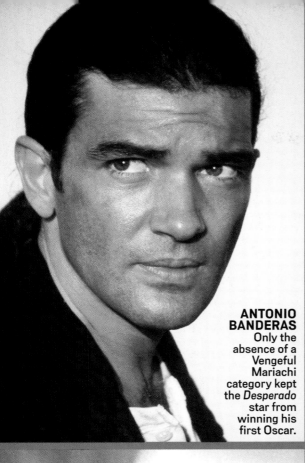

"Watching him up close, literally, my socks fell down"
—*ZORRO* PRODUCER ELIZABETH AVELIAN ON BANDERAS

ANTONIO BANDERAS
Only the absence of a Vengeful Mariachi category kept the *Desperado* star from winning his first Oscar.

JIMMY SMITS
Hired after David Caruso abruptly quit, Smits became *NYPD Blue*'s most arresting officer and helped save the show.

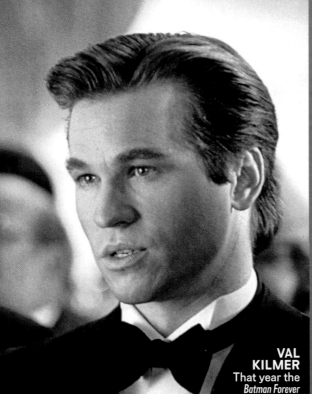

VAL KILMER
That year the *Batman Forever* star's marriage to Joanne Whalley ended in divorce. "Now that he's split up," offered $87 million lottery winner Pam Hiatt, "send him my way."

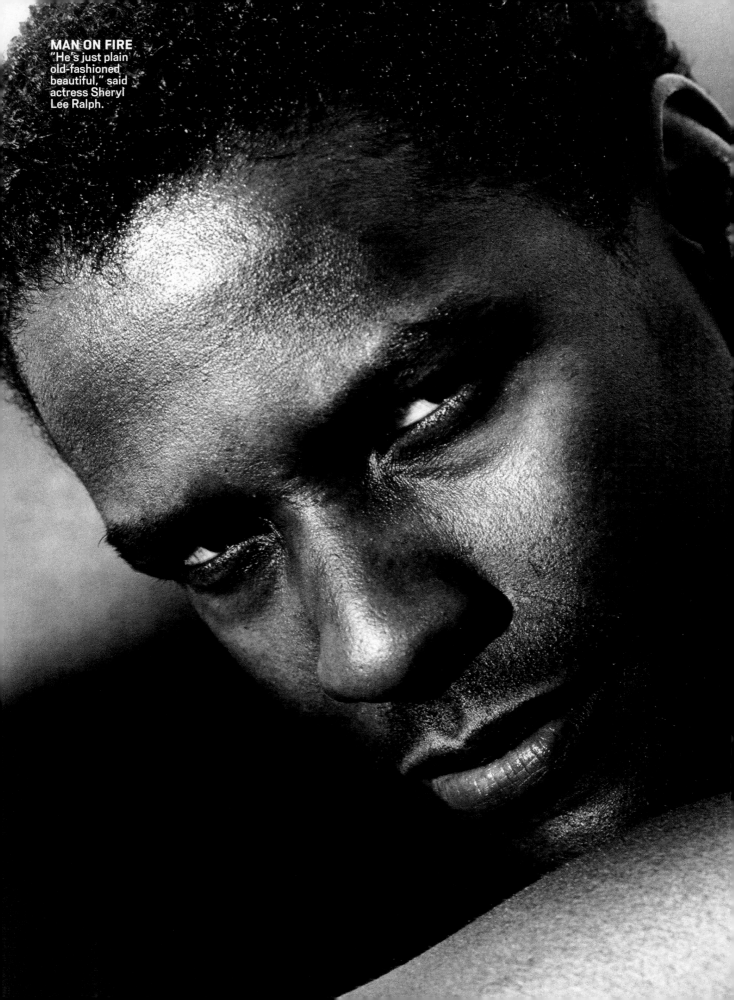

MAN ON FIRE
"He's just plain old-fashioned beautiful," said actress Sheryl Lee Ralph.

"There's something going
on behind the eyes"

DENZEL
WASHINGTON
1996

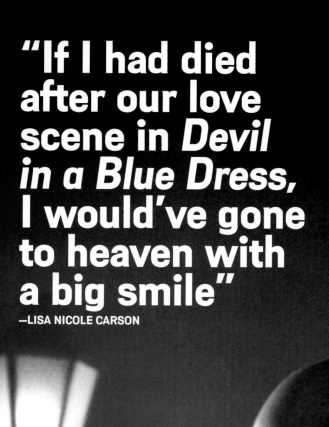

"If I had died after our love scene in *Devil in a Blue Dress*, I would've gone to heaven with a big smile"
—LISA NICOLE CARSON

Devil in a Blue Dress (1995)

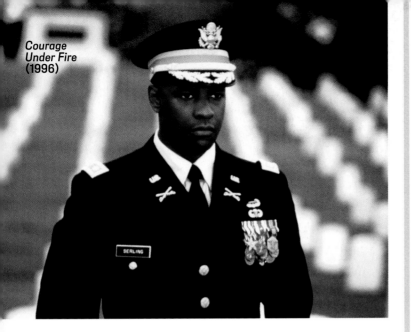

Courage Under Fire (1996)

HIS BIGGEST FAN
JULIA ROBERTS

1993
Lobbies to get Denzel to be her costar in *The Pelican Brief*

1996
Tells PEOPLE that "referring to Denzel Washington as simply sexy is like saying Ernest Hemingway was a good fisherman"

BEFORE THE 2001 OSCARS
"I cannot absorb living in a world where I have an Oscar for Best Actress and Denzel doesn't have one for Best Actor"

2001 OSCARS
Washington wins Best Actor for *Training Day*; possible crisis in space-time continuum averted. Says Roberts: "When we were backstage, Denzel goes, 'I think you were more excited than I was!'"

WAS HE HOT? WAS HE COOL? Did it matter? By 1996, Denzel Washington's quiet fire had made him one of Hollywood's gotta-have-him guys. *Courage Under Fire* costar Regina Taylor appreciated his reserved demeanor: "There's something going on behind the eyes that is at once very accessible but very mysterious." Actress Sheryl Lee Ralph loved his solidness: "It's something you can really put your hands on. And I'm sure a lot of women would like to do just that."

In 1996, Washington starred in *Fire* with Taylor and Meg Ryan (and earned $10 million for the role). Before that, he'd won an Oscar for 1989's *Glory* and received nominations for embodying Steven Biko (*Cry Freedom*, 1987) and Malcolm X (1992). In '93 he joined Tom Hanks in *Philadelphia* and Julia Roberts in *The Pelican Brief*. Roberts told Oprah Winfrey that working with Denzel "was like working with the Beatles. Denzel comes out . . . and [there were] 200 women screaming."

Notably, Washington has that effect even though, scientists have determined, he generally shows less flesh on screen than the average Sexiest Man. Director Spike Lee struggled to get the star to go shirtless for love scenes in 1990's *Mo' Better Blues*. "He'd say, 'I'm a family man. I don't want to do that,'" the director told *USA Today*. Washington has since added director (*Antwone Fisher*) and a Best Actor Oscar (*Training Day*) to his résumé while fully clothed.

The New York native's family consists of four children and actress-wife Pauletta. The couple met on the set of his first professional acting gig, the made-for-TV movie *Wilma,* and married in 1983. Ten years later, in an interview with Barbara Walters, Washington admitted that, when it came to being faithful, "I haven't been perfect—I'll be quite candid about it." Of his wife, however, he said to *The New York Times*, "She is the rock in our marriage." Pauletta told Oprah, "I fell in love with his spirit."

And the rest? Said Pauletta, "I thought, 'Hmmm, not *bad . . .*'" ▌▌

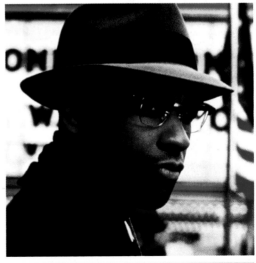

Malcolm X (1992)

RALPH FIENN[...]
Fans saw throu[...]
the disfiguri[...]
makeup he wo[...]
through half of T[...]
English Patie[...]
Asked who was t[...]
sexiest ma[...]
Morgan Fairch[...]
responded, "I lo[...]
Ralph Fiennes[...]

WHO WAS SEXY IN

1996

Jon Bon Jovi
represented
Jersey; Cruise
represented guys
in jerseys

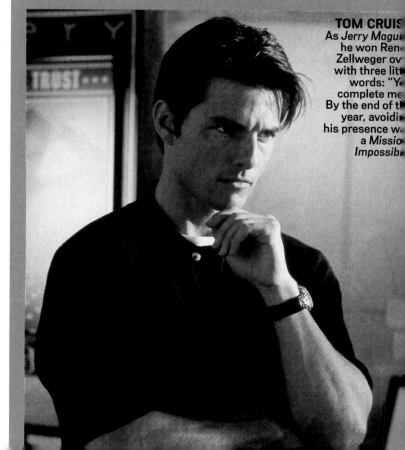

TOM CRUIS[...]
As *Jerry Magui[...]*
he won Ren[...]
Zellweger ov[...]
with three lit[...]
words: "Y[...]
complete me[...]
By the end of t[...]
year, avoidi[...]
his presence w[...]
a *Missio[...]*
Impossib[...]

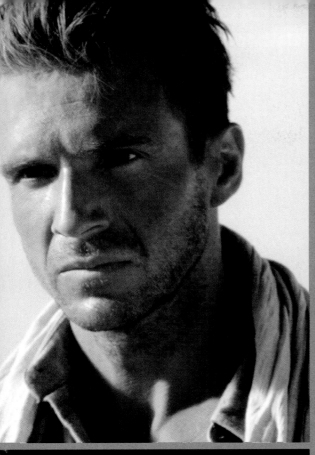

"Matthew would be a star whatever he'd chosen to do"
—JOEL SCHUMACHER

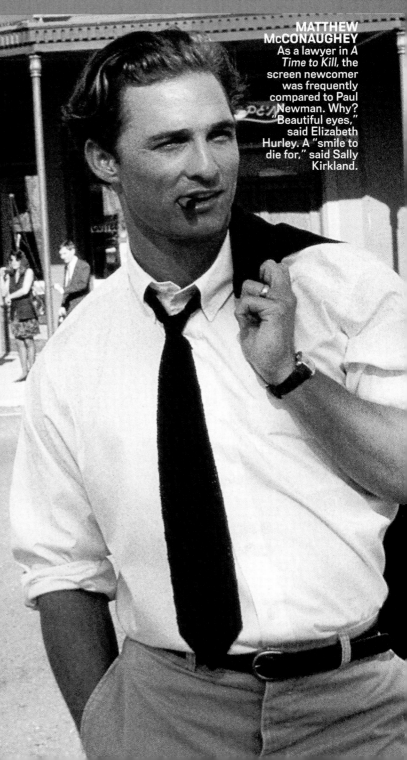

MATTHEW McCONAUGHEY As a lawyer in *A Time to Kill*, the screen newcomer was frequently compared to Paul Newman. Why? "Beautiful eyes," said Elizabeth Hurley. A "smile to die for," said Sally Kirkland.

JON BON JOVI "He's got the most flawless skin," said hairstylist Helena Occhipinti. "His face is very chiseled, with strong bone structure. Of course, he's got great hair too."

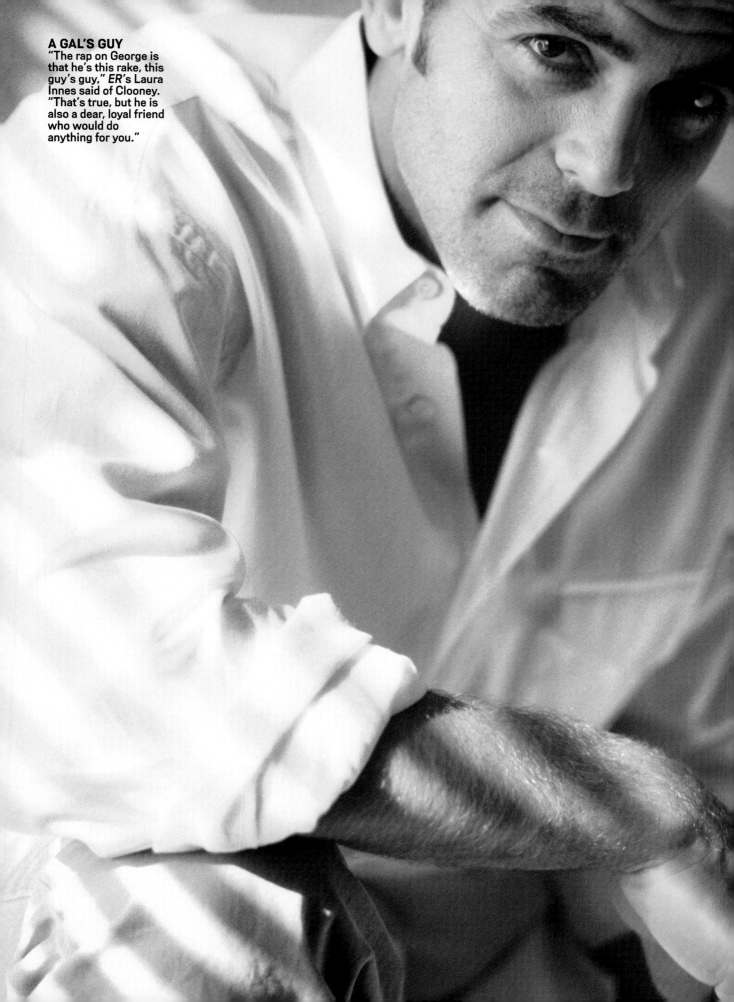

A GAL'S GUY
"The rap on George is that he's this rake, this guy's guy," *ER*'s Laura Innes said of Clooney. "That's true, but he is also a dear, loyal friend who would do anything for you."

'He has a wonderful ability to make a woman weak at her knees'

GEORGE CLOONEY 1997

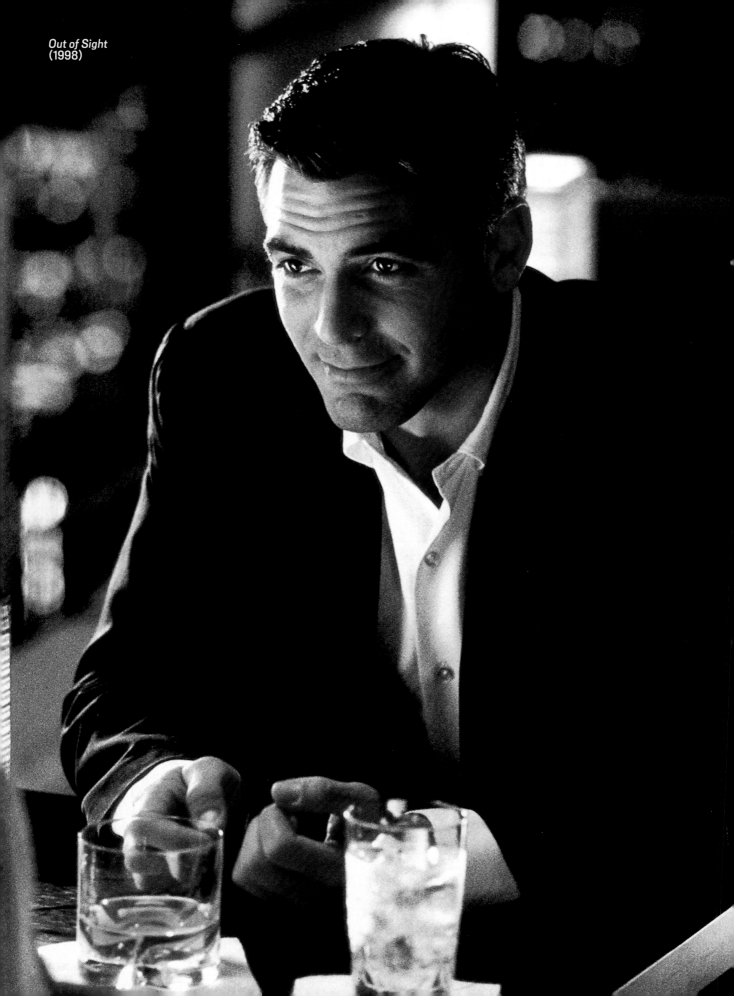

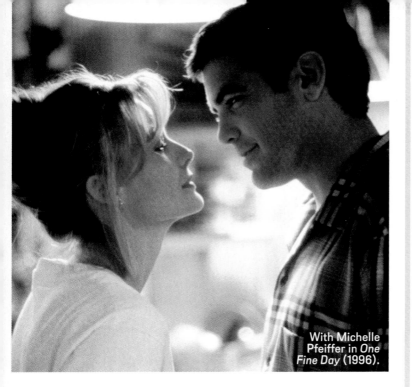

With Michelle Pfeiffer in *One Fine Day* (1996).

"When I go to dinner, I pay for dinner. I don't apologize for it. I can't help it"
—CLOONEY

"He was romantic. He liked to play Nat King Cole music and sing 'Walkin' My Baby Back Home' to me. It was awesome"
—A HIGH SCHOOL GIRLFRIEND

"He made me feel beautiful when I was going through a rough time. He was incredibly gentle. He is incredibly smooth"
—MODEL KAREN DUFFY, ON DATING CLOONEY IN 1995

H IS EYELASHES? "THEY'RE LIKE fans," said his *ER* costar Julianna Margulies. Anything else worth noting? His "big, pretty brown eyes," she says, "stun people when they meet him." Mimi Leder, director of *The Peacemaker,* offered a similar eyewitness account about George Clooney. "It's very hard to look into those eyes," she said, "and not be completely intoxicated."

Join the club. "Girls," recalled his high school baseball coach, "would line up on the street just to watch him walk home." Having grown up on the set of his father's Cincinnati news and talk shows, he got his start in Hollywood at 21 as a live-in chauffeur and handyman for his aunt, legendary jazz singer Rosemary Clooney. Frustrating years in B pictures (*Return of the Killer Tomatoes!*) and failed TV pilots (he made 15) ended when millions began watching him as *ER*'s Dr. Doug Ross in 1994. Married and divorced (from actress Talia Balsam) by then, Clooney, whose more recent companions have included French model Celine Balitran and actress Krista Allen, whom he dated during filming of his directorial debut, 2002's *Confessions of a Dangerous Mind,* has remained a much-in-demand bachelor. "When he turns on that charm," said *ER*'s Yvette Freeman, "oooh, watch out! George can work it when he wants to." Said *One Fine Day* producer Lynda Obst: "He has a wonderful ability to make a woman weak at her knees." Merging smoothly into his boulevardier years, Clooney divides his time between a home on Lake Como in Italy and a Hollywood Hills house he shares with his 150-lb. pet pig Max.

Since leaving *ER* in 1999, he's scored as a director (*Good Night, and Good Luck*), producer (*Syriana*) and actor (*Ocean's Eleven* and *Twelve*). "George is a real blend of brains, humor and charm," said Leder. "He's good-hearted and passionate about his work and his life." ▌▌

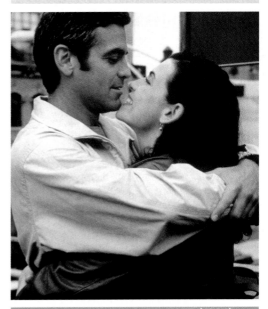

With Julianna Margulies in *ER* (1994).

**RUSSE
CRO**
Love scenes w
Kim Basinge
L.A. Confiden
gained worldw
attention for
Aussie's tal
and, he no
"the freckles
my bu

WHO WAS SEXY IN

1997

Good *Will*, clever Crowe, big iceberg

MATT DAMON
"I'm certainly never going to be anyone's sex symbol," Damon said. *Good Will Hunting* proved him wrong.

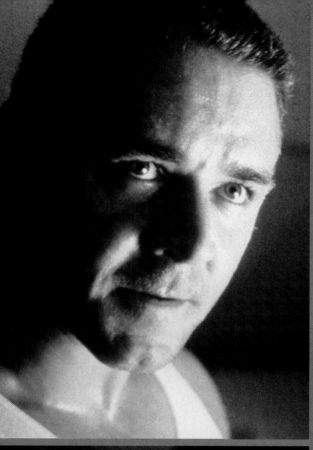

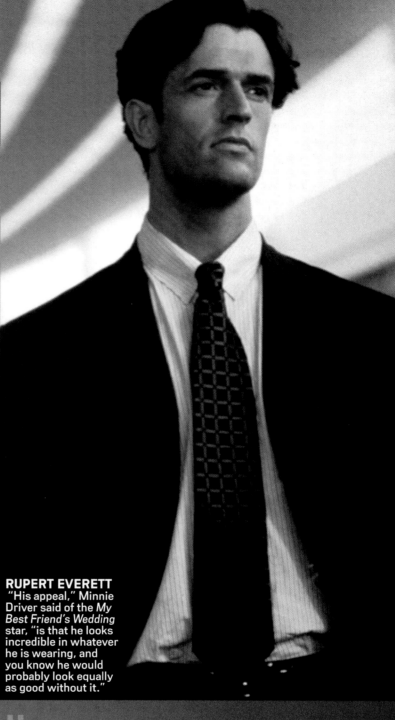

LEONARDO DICAPRIO
"There's a lot going on behind his eyes," said Leo's *Titanic* producer Jon Landau, "very tortured on one hand, with a lot of warmth and humor and sexuality on the other."

RUPERT EVERETT
"His appeal," Minnie Driver said of the *My Best Friend's Wedding* star, "is that he looks incredible in whatever he is wearing, and you know he would probably look equally as good without it."

"Leo has an incredible hold over women"
— JON LANDAU

"He's just so handsome and sweet and elegant and cool and macho"

HARRISON FORD
1998

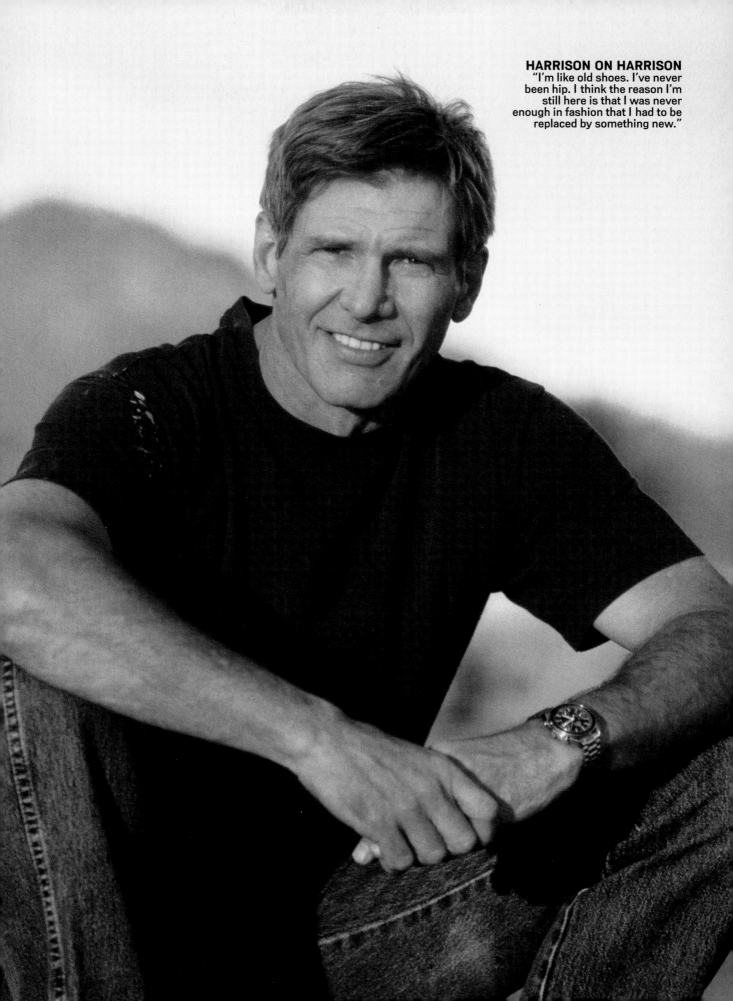

HARRISON ON HARRISON
"I'm like old shoes. I've never been hip. I think the reason I'm still here is that I was never enough in fashion that I had to be replaced by something new."

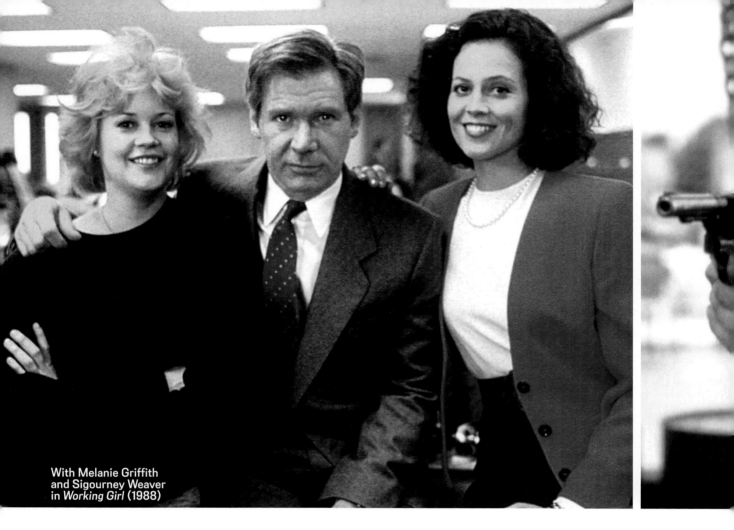

With Melanie Griffith and Sigourney Weaver in *Working Girl* (1988)

HOW HOT WAS HARRISON? TOASTY enough that, on the set of *Working Girl,* costar Melanie Griffith welcomed technical problems that required her to reshoot love scenes. Said Griffith: "I was like, 'No problem, let me get back in that bed.'" Ford, however, claimed confusion when the official sash, crown and epaulettes that go with the Sexiest Man title were metaphorically laid at his feet. "Why this sudden outpouring for geezers?" the then-56-year-old star asked, skeptically. "I never feel sexy. I have a distant relationship with the mirror." But not—aha!—with the camera. After his career took off in 1977, with his turn as the cocky mercenary Han Solo in *Star Wars,* Ford's films (the *Indiana Jones* trilogy, *Patriot Games, Clear and Present Danger* and more than 20 others) collectively grossed more than $2 billion in 20 years. Several were among the Top 30 moneymakers of all time, and his résumé was sprinkled with just enough thrills (*The Fugitive*), drama (*Regarding Henry*), chick flicks (*Working Girl*) and Oscar-nominated performances (*Witness*) to make him a lady's man and a man's man. *Patriot Games* director Phillip Noyce told *The Washington Post,* "Harrison is the way [men] would be if we could be our most heroic selves." With several projects in development, including next year's *Firewall* and the

"My daughter loves him, I adore him, my mother adores him. He spans generations"

—WENDY CREWSON, *AIR FORCE ONE* COSTAR

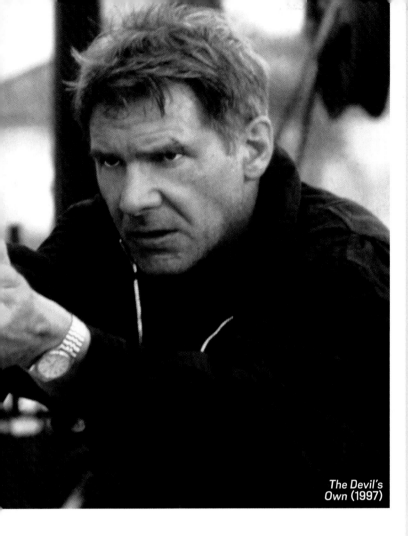

The Devil's
Own (1997)

fourth *Indiana Jones,* one of Hollywood's all-time box office leaders, now 63, shows no signs of slowing.

Up until recently, Ford's personal life had been less action-packed. He'd divorced his college sweetheart, Mary Marquardt, after 15 years in 1979, blaming youth and impatience. But in 2001 he shocked Hollywood watchers when he split with his screenwriter wife of 18 years, Melissa Mathison—the result, he said, of work demands that required too many extended periods away from his family.

In the past the actor was known for being very private, often ducking the media and fans. *Presumed Innocent* costar Bonnie Bedelia remembers strolling with Ford in 1990, when he spotted two women approaching them. "He just grabbed me and pulled me into a doorway," she said. His explanation: "They look like screamers." Following the split with his second wife, the newly single star was less than amused when his personal life became tabloid fodder and reports linked him to actresses Minnie Driver and Lara Flynn Boyle. "[The media] spun the most cloth with the least material," he said.

In 2003, however, the father of four and grandfather of two opened up, announcing to PEOPLE, "I'm in love." The object of his affection was *Ally McBeal* alum Calista Flockhart, now 41, whom he met at the January 2002 Golden Globes. The pair have been going strong ever since and live together in L.A. with Flockhart's 4-year-old son, Liam. He may have been doubtful about our wisdom; she wasn't. "I truly think," said Flockhart, "Harrison is the sexiest man alive." ▐▐

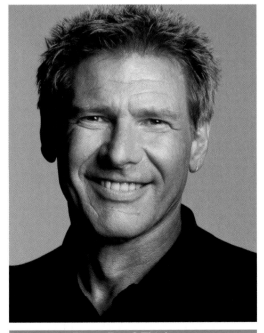

Funny Face? Think not.

WHO WAS SEXY IN
19 98

The truth is out there, and, thanks to Taye Diggs, Stella's missing groove returns to its rightful owner

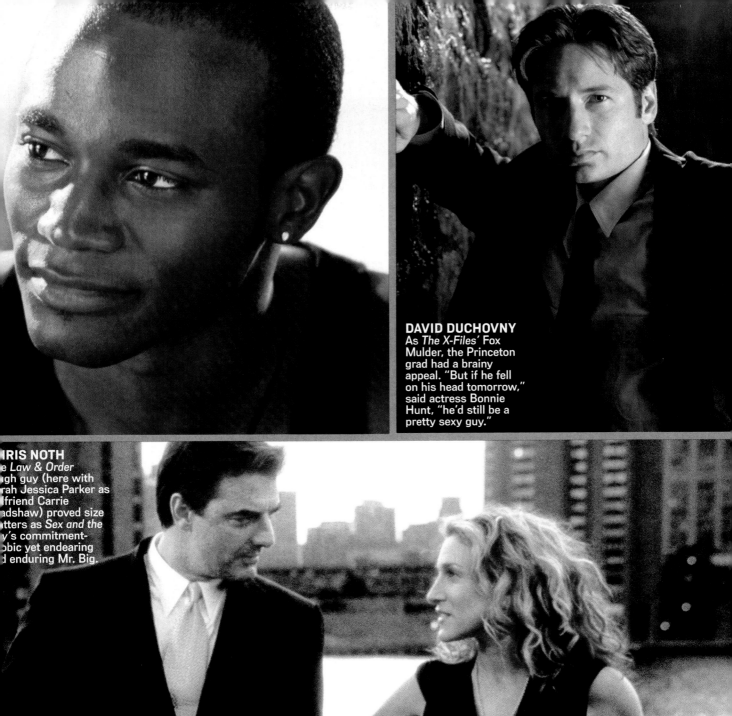

DAVID DUCHOVNY
As *The X-Files'* Fox Mulder, the Princeton grad had a brainy appeal. "But if he fell on his head tomorrow," said actress Bonnie Hunt, "he'd still be a pretty sexy guy."

CHRIS NOTH
The *Law & Order* tough guy (here with Sarah Jessica Parker as girlfriend Carrie Bradshaw) proved size matters as *Sex and the City's* commitment-phobic yet endearing and enduring Mr. Big.

"Richard excels when he's surrounded by women"

RICHARD GERE
1999

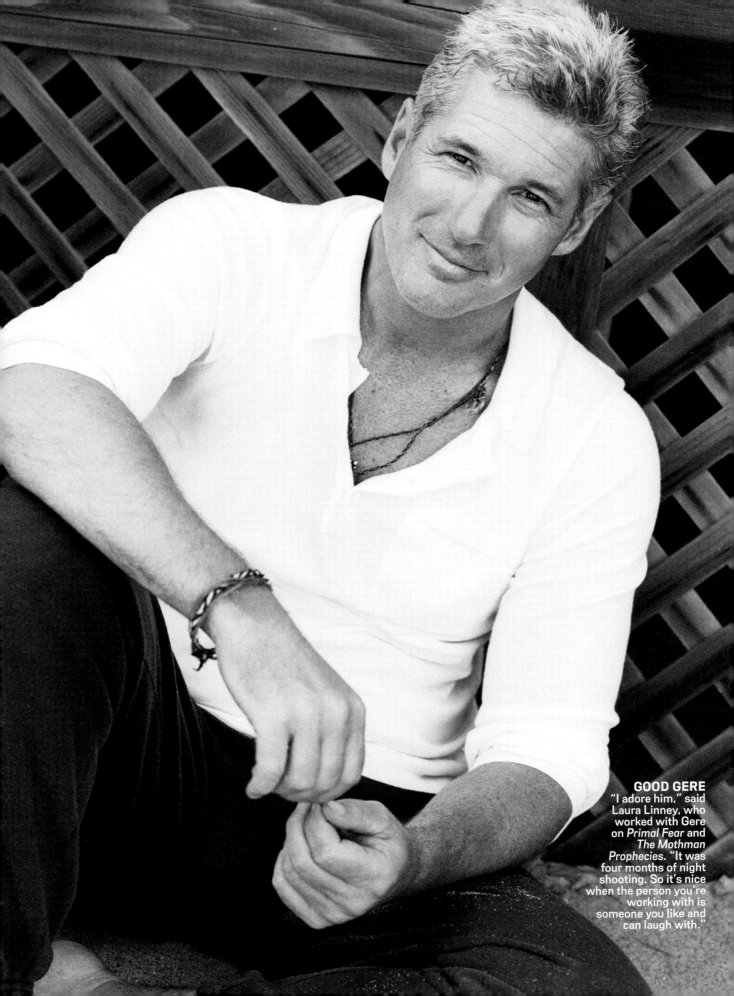

GOOD GERE
"I adore him," said Laura Linney, who worked with Gere on *Primal Fear* and *The Mothman Prophecies.* "It was four months of night shooting. So it's nice when the person you're working with is someone you like and can laugh with."

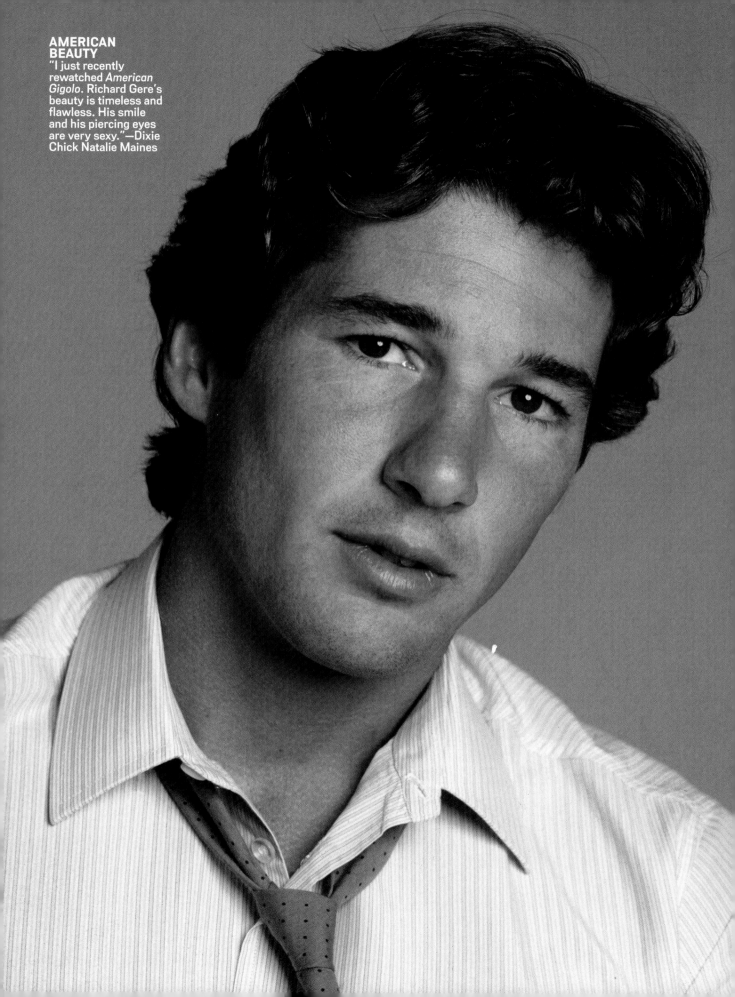

AMERICAN BEAUTY
"I just recently rewatched *American Gigolo*. Richard Gere's beauty is timeless and flawless. His smile and his piercing eyes are very sexy." —Dixie Chick Natalie Maines

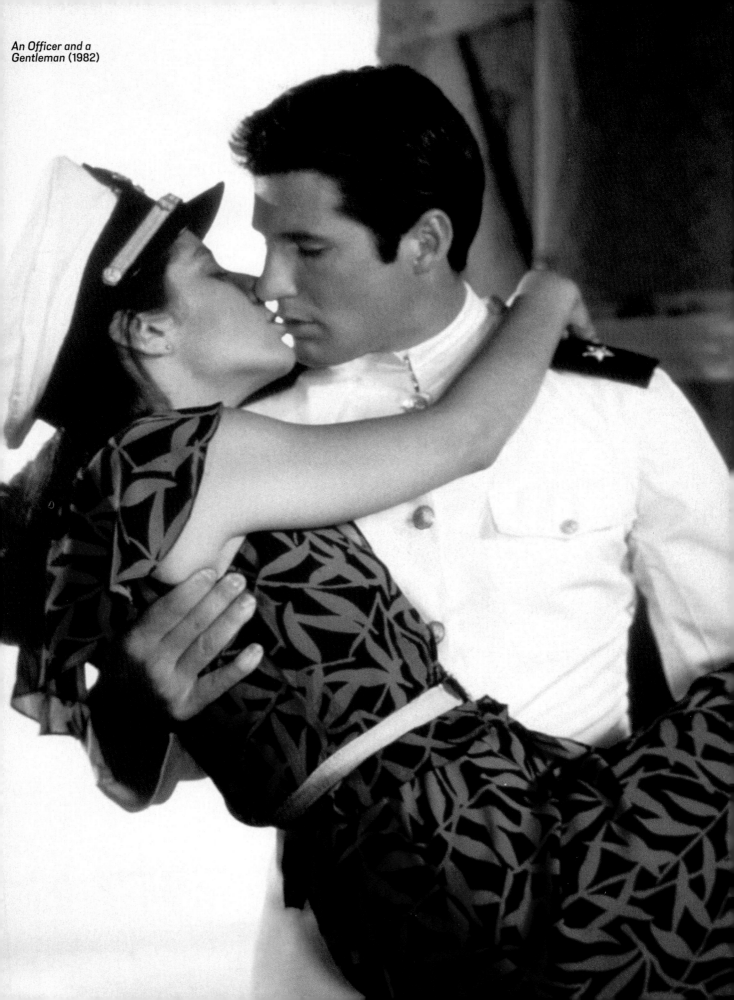

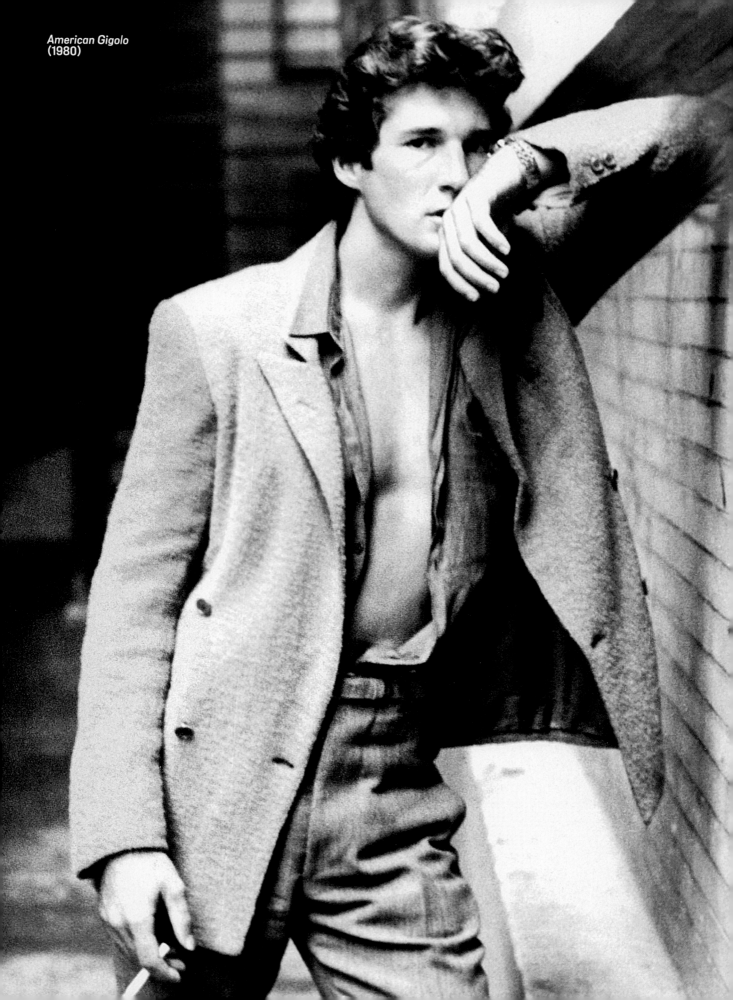

American Gigolo
(1980)

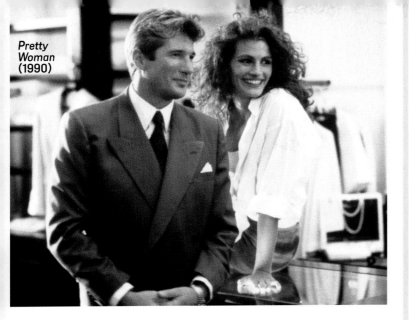

Pretty Woman (1990)

DIRECTOR ROBERT ALTMAN WAS searching for the right guy to star in *Dr. T and the Women*, his 2000 comedy about, of all things, an irresistible obstetric gynecologist. Where might such a man be found? "I picked up a copy of PEOPLE magazine, and on the cover it said 'Richard Gere: The Sexiest Man Alive,'" Altman said later. "And I [said] 'That's our guy!'"

Sexiest Man Alive: The annual honorary designation that *gets results*.

That Nov. 15, 1999, cover appeared almost 20 years after Richard Gere memorably stripped down onscreen. At 50, the *American Gigolo* star had grown up: Divorced from model Cindy Crawford, Gere was about to become a first-time father with actress Carey Lowell and had become friends with, and drawn to the teachings of, the Dalai Lama. Despite the changes, onscreen he still went for the ventricular: a romantic *Autumn in New York* with Winona Ryder and a second honeymoon with his *Pretty Woman* costar Julia Roberts in 1999's *Runaway Bride*. "It's impossible not to adore that man," said Roberts.

This apparently was not a new issue. In hometown Syracuse, N.Y., he had girls "diving at him from across the street," recalled his sister Joanne Gere Rein. He went to college on a gymnastics scholarship but shifted to theater and film. Almost always there seemed to be a beautiful woman within arm's reach: Brazilian artist Sylvia Martins, with Gere for seven years during the 1980s, said she "felt hurt and sad when women started throwing themselves at him." Although Gere tried on different kinds of characters—memorably, a biblical monarch in the flop *King David*—audiences loved him best around beauty. "I think Richard excels when he's surrounded by women," said Lowell, who quietly married Gere in 2002. Case in point: his Golden Globe for *Chicago*, where he danced and sang with Catherine Zeta-Jones and Renée Zellweger. During breaks "I'd hit the treadmill," said Zellweger. "That really got my heart racing, because I could . . . watch Richard Gere work out with weights." Offscreen he tends to his family—including 5-year-old son Homer and Lowell's 15-year-old daughter Hannah—and often speaks out on human rights issues. Says *Dr. T*. costar Farrah Fawcett: "He is just as beautiful on the inside." ▮▮

SPIRITUAL GERE

"The hardest thing, I find, is to have the courage every day to look at myself honestly. We all have a lot of layers, masks, imperfections"
—*HOUSTON CHRONICLE*

"Patience is a great thing I've learned . . . an antidote to anger. Love is an antidote to hatred. I work on love. I work on patience"
—*THE WASHINGTON POST*

"We're all moving away from suffering and toward happiness. We just don't know how to do it, so we mess up every time"
—*USA TODAY*

"We think we know what happiness is, right? You get this and that, and you're in a committed loving relationship, then you'll be happy. But even after you achieve that, you are still not fulfilled. . . . The ultimate happiness is transcendence. It's liberation. It's Buddhahood. It's enlightenment. Whatever your religion is—that's it"
—*THE INDEPENDENT*

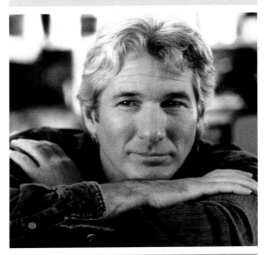

Runaway Bride (1999)

WHO WAS SEXY IN
1999

Lights! Camera! Shake your bon-bon!

RICKY MARTIN
At the Grammys, the man shook, shook, shook and stopped the world. What did Gloria Estefan remember? *"Besides* his fantastic leather pants, his body and his good looks?" she asked.

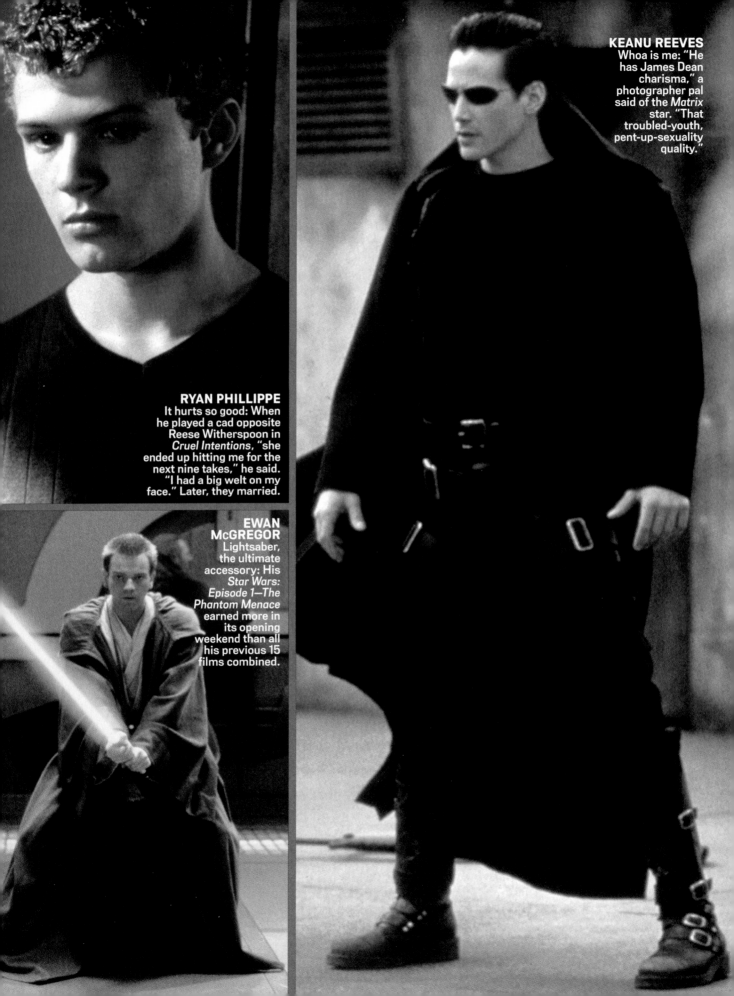

KEANU REEVES
Whoa is me: "He has James Dean charisma," a photographer pal said of the *Matrix* star. "That troubled-youth, pent-up-sexuality quality."

RYAN PHILLIPPE
It hurts so good: When he played a cad opposite Reese Witherspoon in *Cruel Intentions*, "she ended up hitting me for the next nine takes," he said. "I had a big welt on my face." Later, they married.

EWAN McGREGOR
Lightsaber, the ultimate accessory: His *Star Wars: Episode 1—The Phantom Menace* earned more in its opening weekend than all his previous 15 films combined.

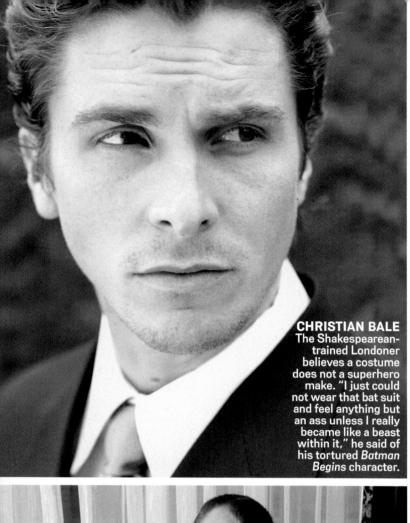

CHRISTIAN BALE
The Shakespearean-trained Londoner believes a costume does not a superhero make. "I just could not wear that bat suit and feel anything but an ass unless I really became like a beast within it," he said of his tortured *Batman Begins* character.

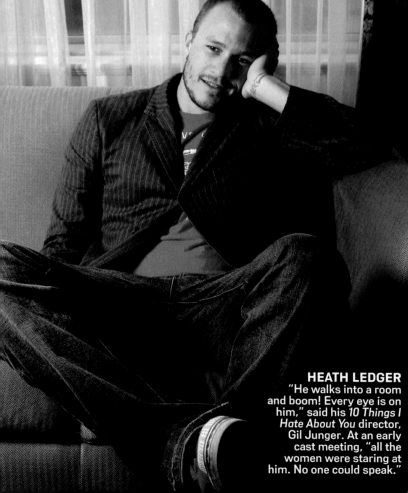

HEATH LEDGER
"He walks into a room and boom! Every eye is on him," said his *10 Things I Hate About You* director, Gil Junger. At an early cast meeting, "all the women were staring at him. No one could speak."

Give me your tired, your poor, your huddled masses . . . and, while you're at it, could you toss in a few stubbly guys with cool accents?

IMP

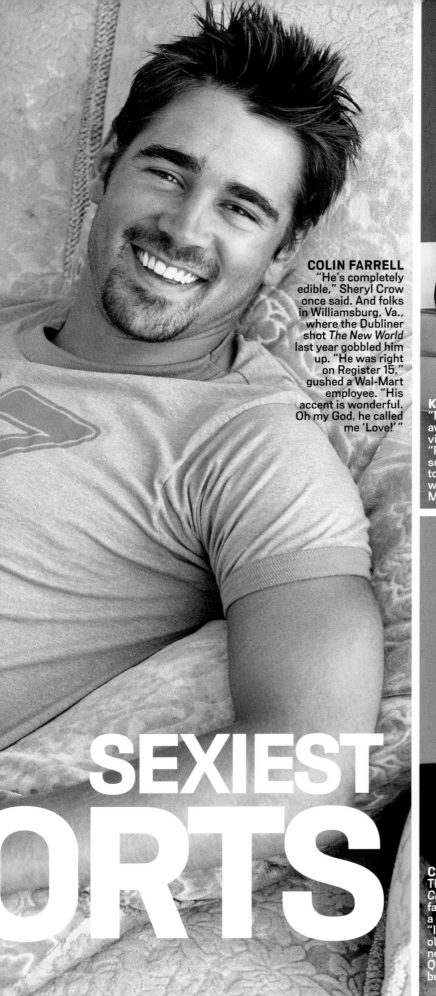

COLIN FARRELL
"He's completely edible," Sheryl Crow once said. And folks in Williamsburg, Va., where the Dubliner shot *The New World* last year gobbled him up. "He was right on Register 15," gushed a Wal-Mart employee. "His accent is wonderful. Oh my God, he called me 'Love!'"

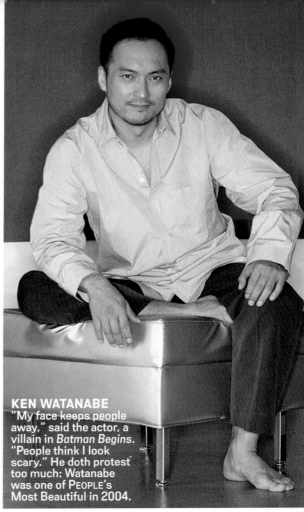

KEN WATANABE
"My face keeps people away," said the actor, a villain in *Batman Begins*. "People think I look scary." He doth protest too much: Watanabe was one of PEOPLE's Most Beautiful in 2004.

SEXIEST
ORTS

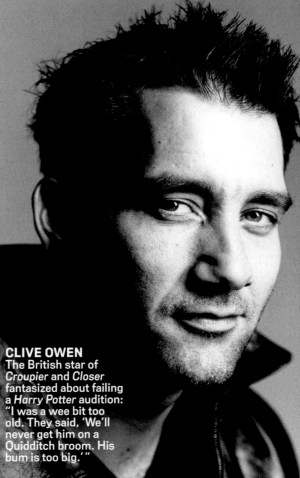

CLIVE OWEN
The British star of *Croupier* and *Closer* fantasized about failing a *Harry Potter* audition: "I was a wee bit too old. They said, 'We'll never get him on a Quidditch broom. His bum is too big.'"

IT WAS AN ELECTION YEAR OF HANGING CHADS

and dangling Toms: Cruise was on his second *Mission: Impossible,* and Hanks was clinging for dear life to a coconut in *Cast Away.* Meanwhile *Snatch,* Brad Pitt's dark-horse entry, never left the gate. Still, Pitt did star in the year's biggest Hollywood extravaganza: his midsummer wedding to America's sweetheart, Jennifer Aniston. "Marrying Jennifer was the pinnacle for him," said his *Meet Joe Black* costar Marcia Gay Harden. "Sexiness isn't just about the single bachelor and good looks. There's something gorgeous about his commitment."

Perhaps perceiving that he had achieved an unsurpassable pinnacle of pulchritude—he had also been named PEOPLE's Sexiest Man in '95—he began campaigning vigorously against type. "I don't want to be Brad Pitt the pinup anymore," he said, offsetting his ripped torso in 1999's *Fight Club* with a shaved head and chipped tooth. For his role as a mesmerizing mumbler in *Snatch,* "he sometimes didn't shower for days" and "wallowed four feet deep in mud with his nose made up to look broken and his fingernails torn," said a crew member.

In ensuing years Pitt appeared in box office smashes like *Ocean's Eleven* and *Twelve, Troy* and *Mr. & Mrs. Smith,* the film that paired him, for better or worse, with Angelina Jolie, the formidable beauty who, by some accounts, proved the nemesis of his marriage. Meanwhile, fans needn't worry that his second Sexiest title went to his head. "'Betty, what was the name of that movie I didn't like?'" Pitt recalled his grandfather asking his wife about one of Brad's flicks. "I thought that was just classic," Pitt said. "If that doesn't keep your feet on the ground," he said, "what would?"

SEXIEST MAN'S *ONLY* DOUBLE HONOREE
BRAD PITT

2000

Fight Club (1999)

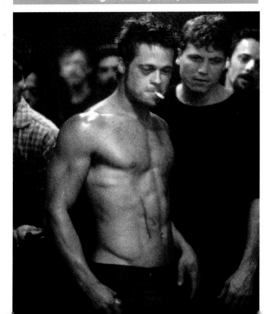

WHO WAS SEXY IN 2000

New Wonders from Down Under, and a former *Law*man proved to be boot camp buff

RUSSELL CROWE
Maximum Maximus: On his signal, movie-goers unleashed a resounding "Hell-O Mr. Crowe!"

BENJAMIN BRATT
Tanks, Ben: He left *Law & Order* to play a drug dealer in *Traffic*, then followed up as a fine Fed in *Miss Congeniality*.

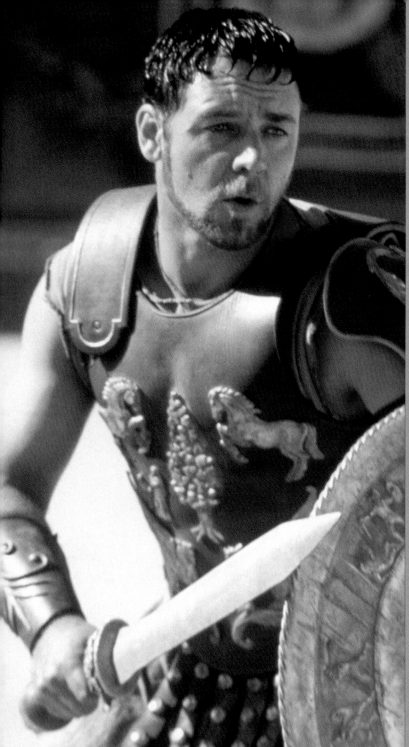

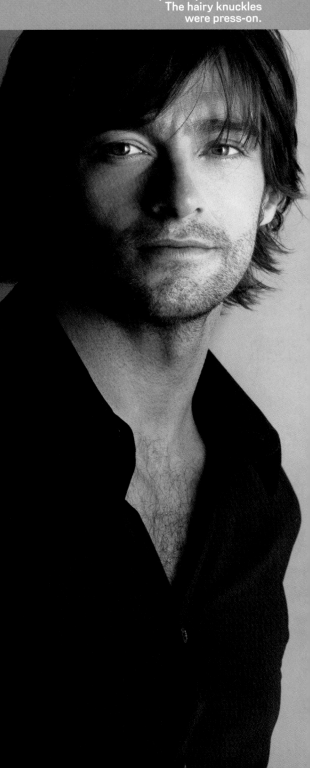

"Hugh's the perfect man, talented, bright and sexy as hell"
—REBECCA ROMIJN

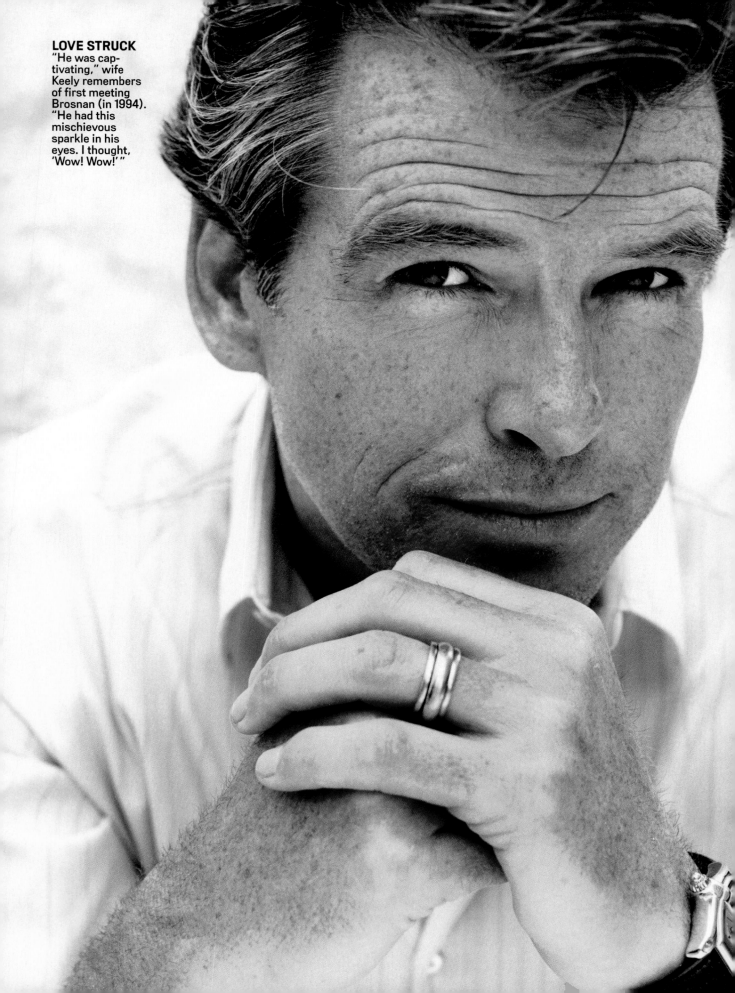

LOVE STRUCK "He was captivating," wife Keely remembers of first meeting Brosnan (in 1994). "He had this mischievous sparkle in his eyes. I thought, 'Wow! Wow!'"

"He's genuine, he's gorgeous, and he's also funny—like Cary Grant"

PIERCE BROSNAN
2001

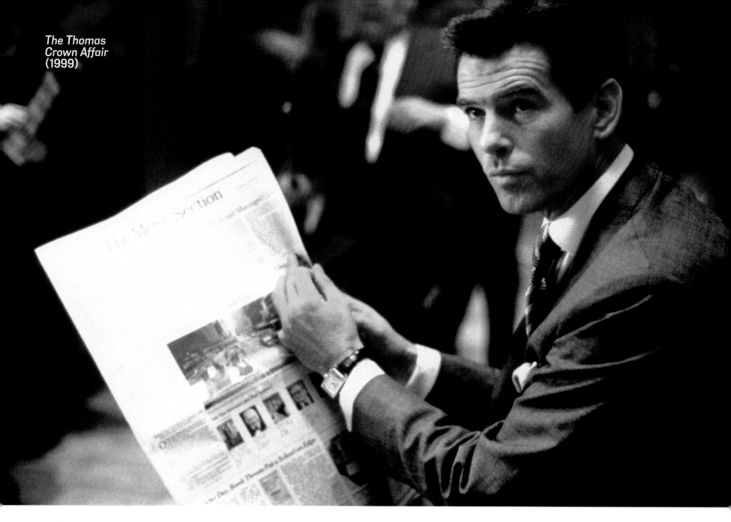

The Thomas Crown Affair (1999)

ONLY A SMALL, ELITE FRATERNITY can speak with authority about that special feeling. Put another way: It's a Sexiest Man thing; you wouldn't understand. "I immediately felt sexier," jokes Pierce Brosnan, recalling his reaction to getting the title in November 2001. "Every fiber of my being perked up. My family didn't recognize me." Slightly more seriously, he adds, "I was very honored, flattered and humored by it." It was, sadly, a year in our nation's history when grace and humor were at a premium; Brosnan filled the bill. "When you see a gorgeous man holding hands with his wife and holding his baby," said his *Evelyn* costar Julianna Margulies, "there's nothing more sexy in the world."

There's much to be said as well for the dash and cool he brought to his most famous role. His four outings as 007 returned to a moribund franchise its license to kill at the box office. "He's a natural James Bond," said coproducer Barbara Broccoli, who first cast him as the Walther-packing secret agent who left fans stirred, not shaken, in 1995's *GoldenEye*. "He's genuine, he's gorgeous, and he's also funny—like Cary Grant," said Rene Russo, his costar in 1999's *The Thomas Crown Affair*. He first displayed his debonair appeal on NBC's *Remington Steele* in the 1980s.

"I've seen him in line for cappuccino looking absolutely beautiful"
—LINDA HAMILTON

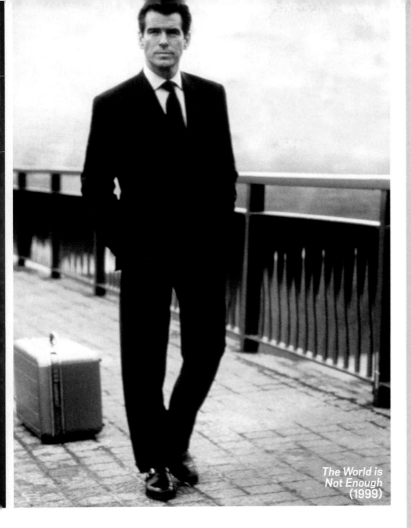

The World is Not Enough (1999)

BOND IN THE BUFF

"We both had to be pretty much nude. He walks in with a silver tray with champagne and two glasses. This was not part of the script. 'Okay,' he says, 'let's have a little drink.' Oh, it was great!"
—*THOMAS CROWN AFFAIR* COSTAR RENE RUSSO

"Believe me, I have pictures of Pierce seared in my memory"
—RUSSO, ON SHOOTING A NUDE SCENE WITH BROSNAN

"I like to say to him, 'We want to get you stripped to the waist and wet.' Because he looks fantastic wet—and dry. He's got a great chest and physique"
—BOND COPRODUCER BARBARA BROCCOLI

GoldenEye (1995)

Fans also felt for a man who had suffered personal tragedy. In 1991 Cassandra, Brosnan's wife of 11 years, the mother of his son and two adopted stepchildren, died in his arms, the victim of ovarian cancer. "The children helped enormously" in his healing, Brosnan told PEOPLE. "But there's no escaping the pain. You have to sit in it, accept it, then you have to move out of it."

Two years later he fell in love with then *Today* show correspondent Keely Shaye Smith. They had two sons together and wed in August 2001. "I understand why women find him sexy," Smith said a few months later, when her new groom was crowned Sexiest Man. "He is an appealing man. He really likes and appreciates women." Born poor in rural Ireland and abandoned by his own father before his second birthday, Brosnan, who was raised by his mother, a nurse, in London, reckoned that having grown up without a dad is "why I enjoy family life so much and being the father I am."

Last year his run as Bond ended with a surprise phone call. He said he was fired over creative differences; producers said they balked at his contract demands. Even so, at 52, Brosnan has found an alternate outlet for his Bonded cool as *The Thomas Crown Affair*'s suave thief, a role he will repeat in the upcoming sequel, *The Topkapi Affair*. He also takes a turn as an anti-Bond assassin in the black comedy *The Matador*. What does it take to maintain that Sexiest Man appeal? "Don't take yourself too seriously," he says, "and keep a twinkle in the old eye."

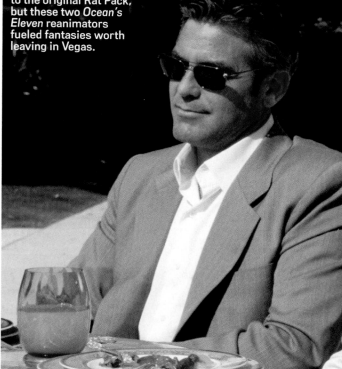

ORLANDO BLOOM
As the valiant archer elf in *The Lord of the Rings,* he stirred puppy love in young fans as well as actress Amanda Bynes. "He has gorgeous eyes, and his accent is sweet," she said. "And I know he loves dogs."

WHO WAS SEXY IN
20 01

Orlando bloomed; in theaters, the magic number was *Eleven*

GEORGE CLOONEY AND BRAD PITT
A gathering of eagles, er, Sexiest Men: No offense to the original Rat Pack, but these two *Ocean's Eleven* reanimators fueled fantasies worth leaving in Vegas.

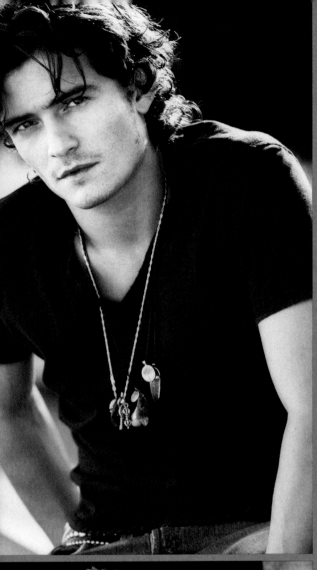

JOSH HARTNETT
"I can't think of anyone else I'd rather look at onscreen," said Sofia Coppola, who directed the *Pearl Harbor* star in *The Virgin Suicides* in 1998.

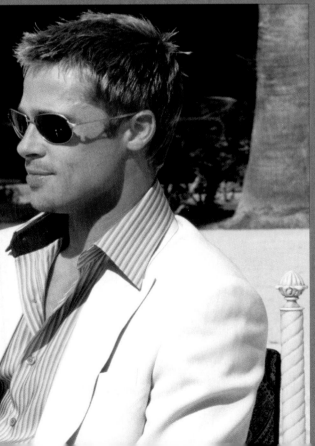

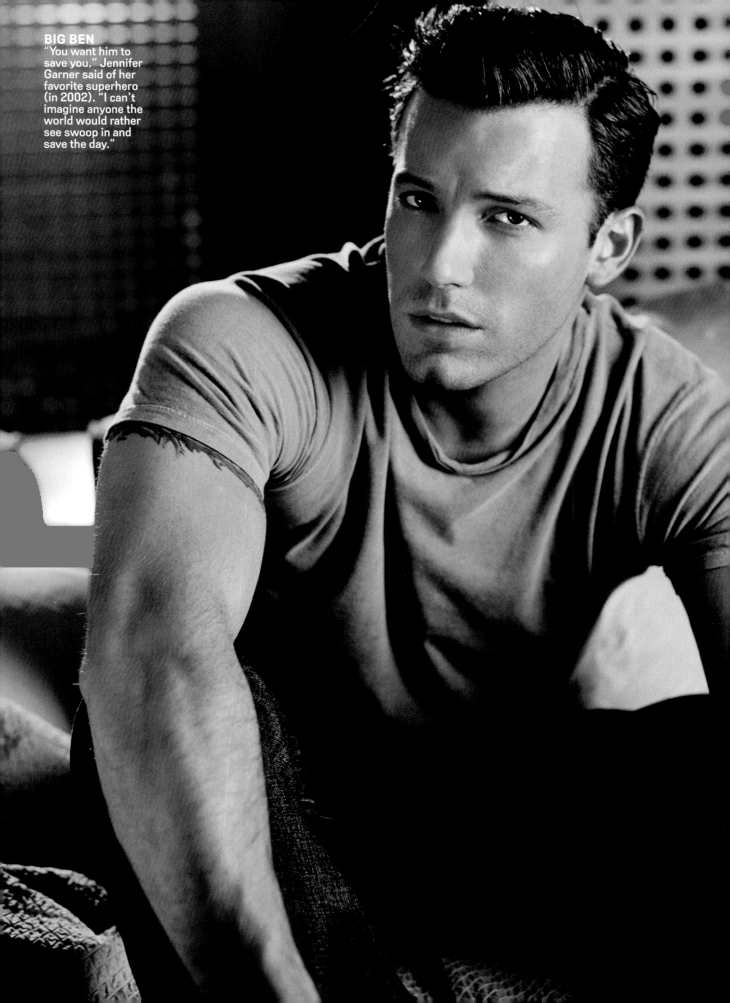

BIG BEN
"You want him to save you," Jennifer Garner said of her favorite superhero (in 2002). "I can't imagine anyone the world would rather see swoop in and save the day."

"He's your basic
tall, dark and
handsome…He's it"

BEN AFFLECK
2002

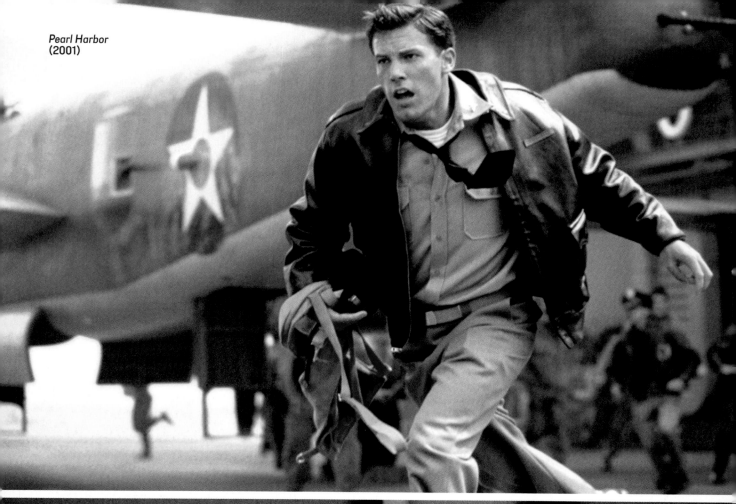

Pearl Harbor
(2001)

Gigli
(2003)

"He's the ideal man: chatty, gorgeous, generous and intelligent"
—DIRECTOR KEVIN SMITH

SURE, TOBEY MAGUIRE IN *SPIDER-man* and Orlando Bloom and Viggo Mortensen in *The Lord of the Rings: The Two Towers* were vanquishing his efforts—*The Sum of All Fears* and *Changing Lanes*—at the box office. But, for better or worse, in 2002 Ben Affleck still won the headline war, thanks in part to the media glory that was Bennifer—as the press dubbed his bling-dripping, Bentley-driven, paparazzi-documented 18-month romance with Jennifer Lopez. What did she see in him? Perhaps exactly what other women saw. When he decked himself in red-leather tights and walked onto the set of his superhero flick *Daredevil,* "we all swooned," said costar Jennifer Garner. "He's your basic tall, dark and handsome. . . . He's it."

Three years later, she married him.

Liv Tyler, Affleck's love interest in 1998's Armageddon, echoed Garner: "He's soooo strong." Anything else? "Ben has this nerdy smart-guy side to him," Tyler said. "He reads a lot. He's really interested in knowing more about the world." Affleck grew up in the milieu he and boyhood buddy Matt Damon mined in their 1997 Oscar-winning script *Good Will Hunting*—about two blue-collar kids in Cambridge, Mass., home to Harvard, where Ben's father, Tim, like Damon's character in the film, once worked as a custodian. "'Oh, Ben, you should go to college,'" his mother, Chris, said when he quit the University of Vermont and headed to Hollywood. "But secretly I suspected that he was going to make it."

Mom was right: Ben was soon adding movie credits (*Dazed and Confused, Chasing Amy*) and getting a taste of the tabloid times ahead with his volatile one-year romance with Gwyneth Paltrow. Then came *Gigli,* the film that unleashed Bennifer upon an unsuspecting world. Sadly, the relationship with J. Lo didn't outlast his Sexiest reign. In September 2003 the couple canceled their $2 million wedding and soon called it quits. Happily, Affleck, back in tights in *Truth, Justice and the American Way,* about TV Superman George Reeves, wed Garner in a decidedly non-Affleck manner—quietly—in June 2005. With the couple expecting their first child at press time, Affleck is realizing his ultimate ambition. "What's going to mean the most to me," he said, "is being a father, being a husband, being a person of whom I can really be proud."

IT'S ALL ABOUT THE BENJAMIN

"Ben's really loyal and really honest, really smart, really funny. He's got more going for him than just about anyone I've ever met"
—**MATT DAMON**

Ben and Matt "weren't considered cool kids. They were drama geeks"
—**MATT'S BROTHER KYLE**

On the first day on the *Good Will Hunting* set, "Matt and Ben cried. They had believed in it so much"
—**COPRODUCER CHRIS MOORE**

"He's a hugger. He loves being around people. You can't fake that kind of warmth"
—*THE SUM OF ALL FEARS* **DIRECTOR PHIL ALDEN ROBINSON**

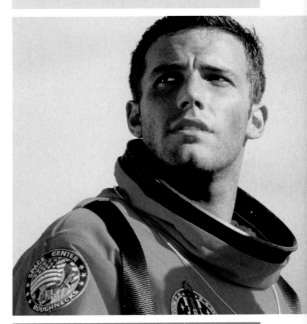

Armageddon (1998)

WHO WAS SEXY IN

2002

In the year of Potter and hobbits, Maguire spun a blockbuster and Olivier warmed the extra-marital bed

LENNY KRAVITZ
He sang the musical question, "Are you gonna go my way?" For many, the answer was yes or...yes.

"He's
wonderful,
he's wild"
—BRIDGET MOYNAHAN,
COLIN FARRELL'S COSTAR
IN *THE RECRUIT*

TOBEY MAGUIRE
The geeky kid
from *Pleasantville*
and *The Cider House
Rules* reinvented
himself as *Spider-
Man*'s ripped
arachnoid hero.

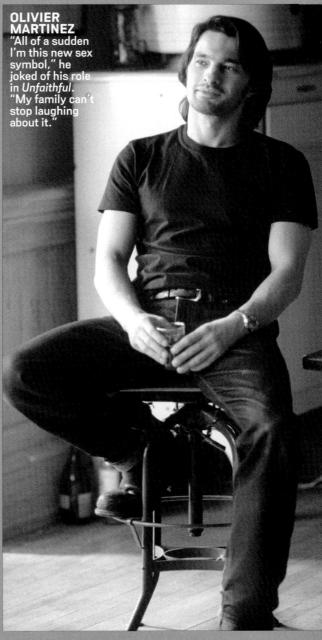

**OLIVIER
MARTINEZ**
"All of a sudden
I'm this new sex
symbol," he
joked of his role
in *Unfaithful*.
"My family can't
stop laughing
about it."

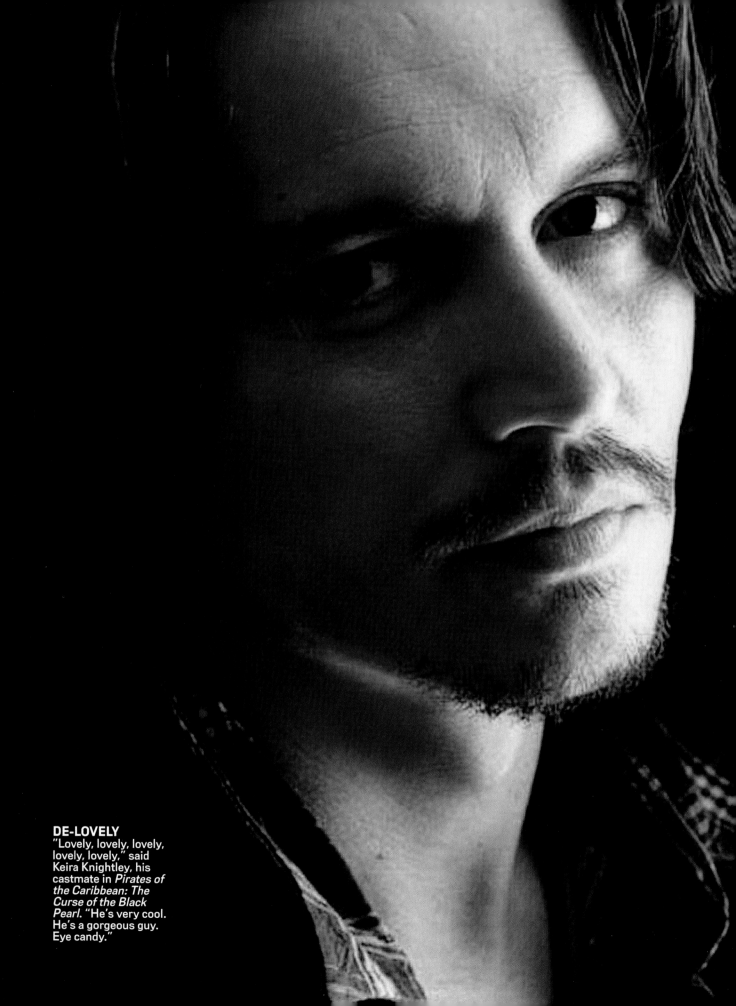

DE-LOVELY
"Lovely, lovely, lovely, lovely, lovely," said Keira Knightley, his castmate in *Pirates of the Caribbean: The Curse of the Black Pearl.* "He's very cool. He's a gorgeous guy. Eye candy."

"Life's pretty good.
And why wouldn't it be?
I'm a pirate"

JOHNNY DEPP
2003

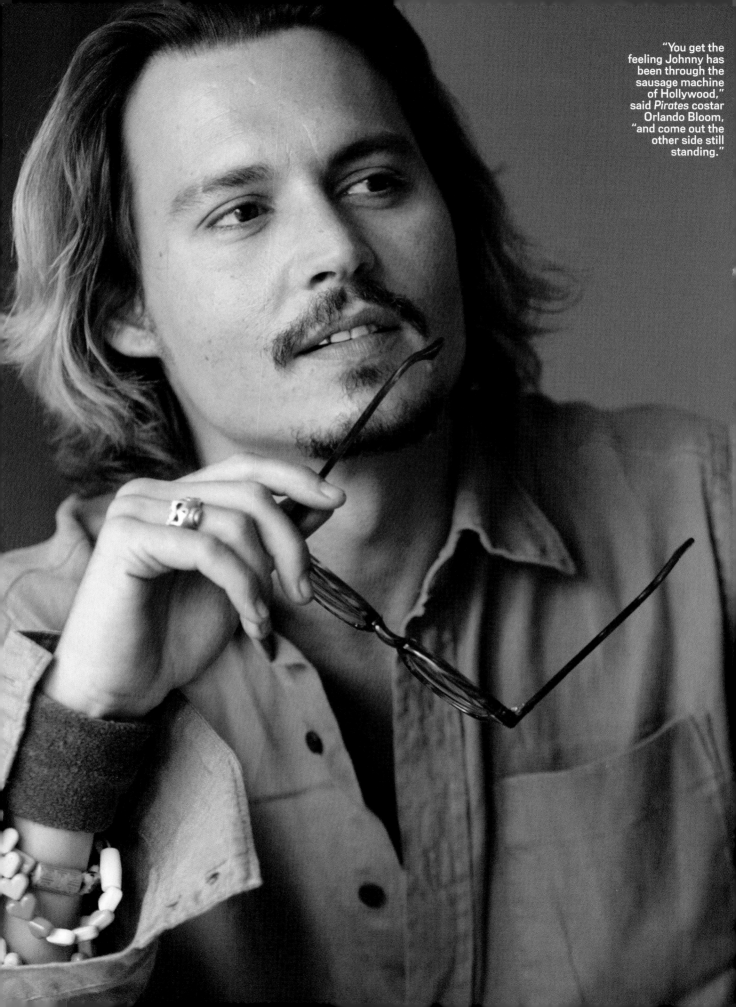

"You get the feeling Johnny has been through the sausage machine of Hollywood," said *Pirates* costar Orlando Bloom, "and come out the other side still standing."

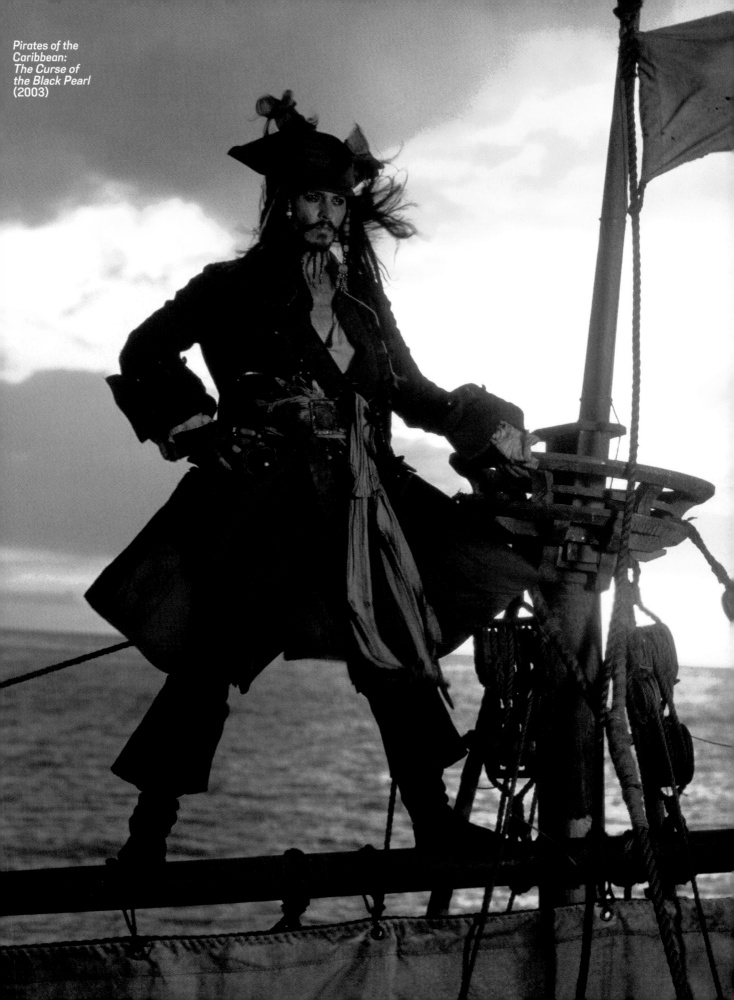

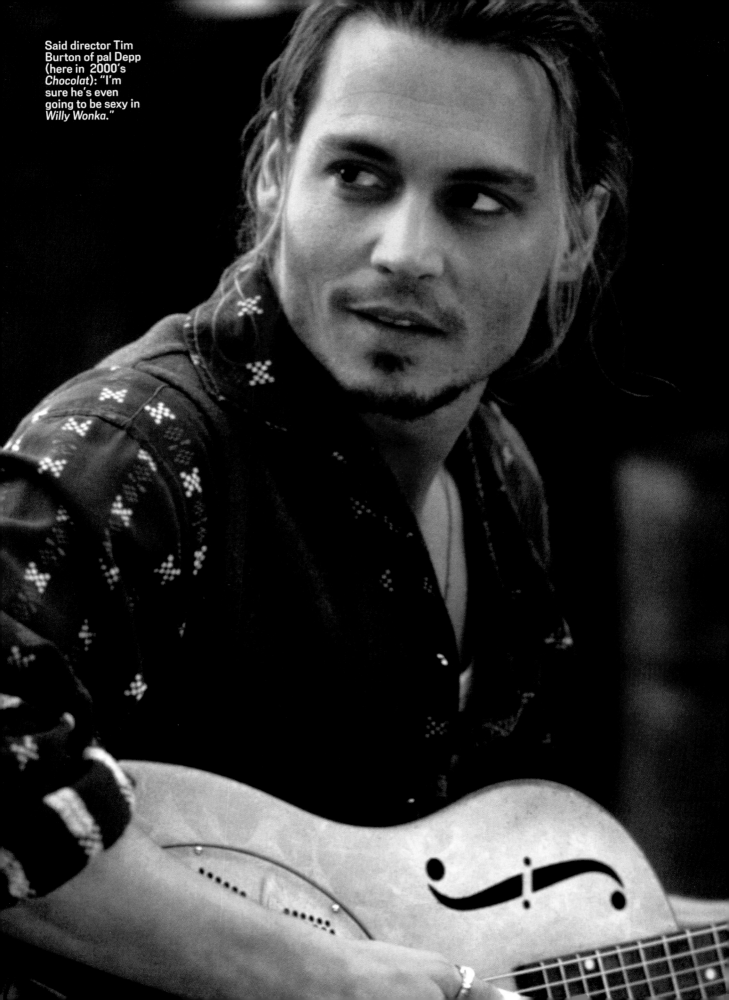

Said director Tim Burton of pal Depp (here in 2000's *Chocolat*): "I'm sure he's even going to be sexy in *Willy Wonka*."

"He's always been a bit of a rebel....That's very sexy"

—CHRISTINA RICCI

STRANGE BUT TRUE: JOHNNY DEPP is the *first* person to play an ambiguously gay pirate, with mascaraed eyelids, beaded hair and the swagger of legendary rocker Keith Richards, to be named Sexiest Man Alive—and to scare the daylights out of Disney execs. "There were a couple who were very worried," Depp told a reporter. "Like, 'Why is he acting like that? Is the character a complete homosexual? He's ruining the movie!'" Depp's response: "Trust me." They did. More than $300 million later, *Pirates of the Caribbean: The Curse of the Black Pearl* was Depp's most commercially successful film in a career famous for choices—from *Edward Scissorhands* to *Ed Wood*—both quirky and daring. "He follows his own thing," said *Fear and Loathing in Las Vegas* author Hunter S. Thompson. *Pirates* also brought Depp, at 40, his first Oscar nomination. His reaction? Joked *Fear* director Terry Gilliam: "Johnny told me that selling out was really quite pleasurable."

When the Kentucky native left high school at 16 and moved to L.A., he wanted a record deal, not a movie. Instead, fate, and first wife Lori Allison, led him to her friend Nicolas Cage. (The couple split in 1985.) Cage sent Depp to his agent, which led to a small part in 1984's *A Nightmare on Elm Street*, and one in *Platoon* in '86. But TV provided Depp with his breakout role. He landed on FOX's *21 Jump Street* in '87, and his handsome mug was plastered on the covers of teen zines nationwide. By the show's third season he'd had enough. "Some people, when they get attention in the public eye, they stand a bit taller," he said in an interview with the *Los Angeles Times*. "I shrink and kind of hide."

During the '90s Depp was in danger of losing it all. He admitted in an interview with *USA Today* to using drugs and alcohol and got arrested—twice. "I was doing a pretty good job of destroying myself," he told *Details*. "Johnny's a little dangerous," said director Lasse Hallström (*Chocolat*). "That's the key to his appeal."

Just ask French pop star Vanessa Paradis. The two met in 1994, reconnected in '98 and had daughter Lily-Rose in '99 and son Jack in 2002. "Life's pretty good," said Depp, who has two *Pirates* sequels in the works and recently teamed again with director Tim Burton (*Scissorhands*, *Ed Wood*, *Charlie and the Chocolate Factory*) on the animated *Corpse Bride*. "And why wouldn't it be? I'm a pirate, after all."

21 Jump Street

WHO WAS SEXY IN 2003

Justin goes solo and *That '70s* kid dates Demi— but neither one is the One

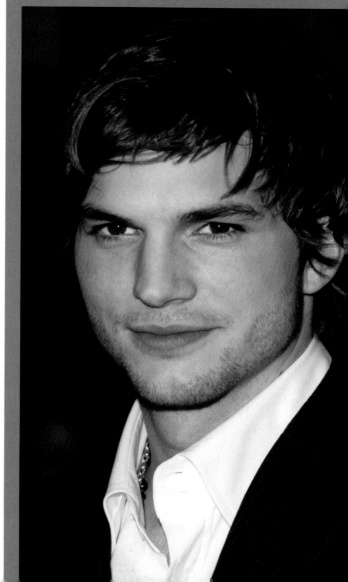

ASHTON KUTCHER
Kutchy-coo: "If you walk into a bar with Ashton, you're going to be invisible," said director David Zucker. "He's striking, but has a personality that disarms you. Women love him."

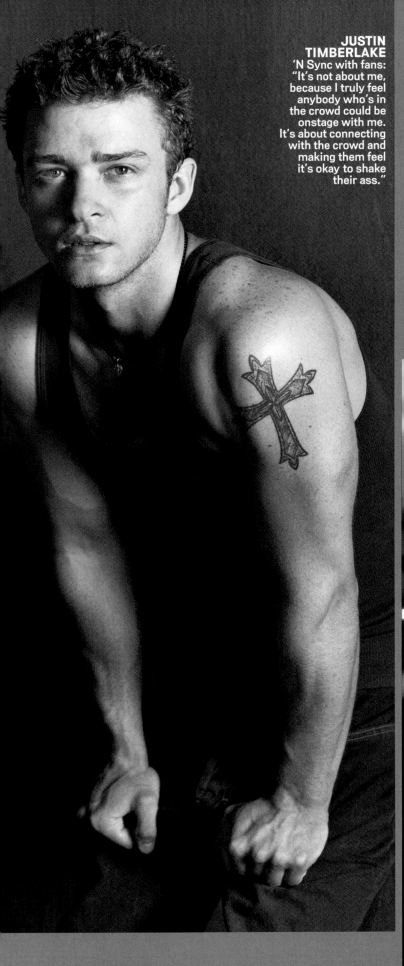

"I enjoy my life, and I think that's why I'm ahead of the game"
—JUSTIN TIMBERLAKE

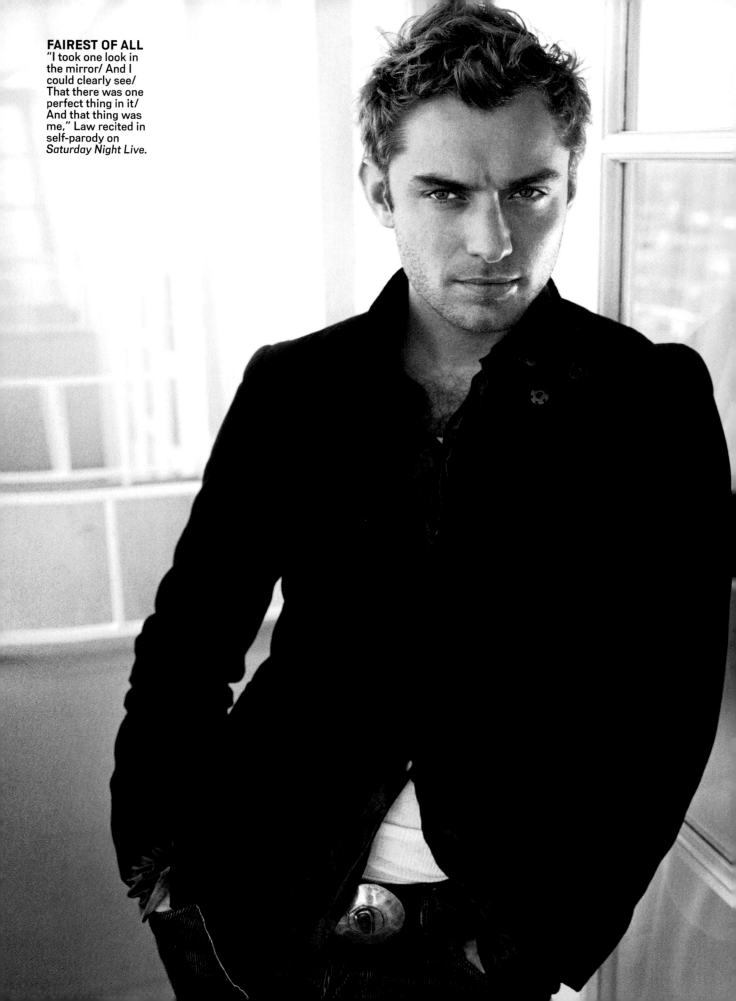

FAIREST OF ALL
"I took one look in the mirror/ And I could clearly see/ That there was one perfect thing in it/ And that thing was me," Law recited in self-parody on *Saturday Night Live.*

"He's the most beautiful man who ever walked the earth"

JUDE LAW
2004

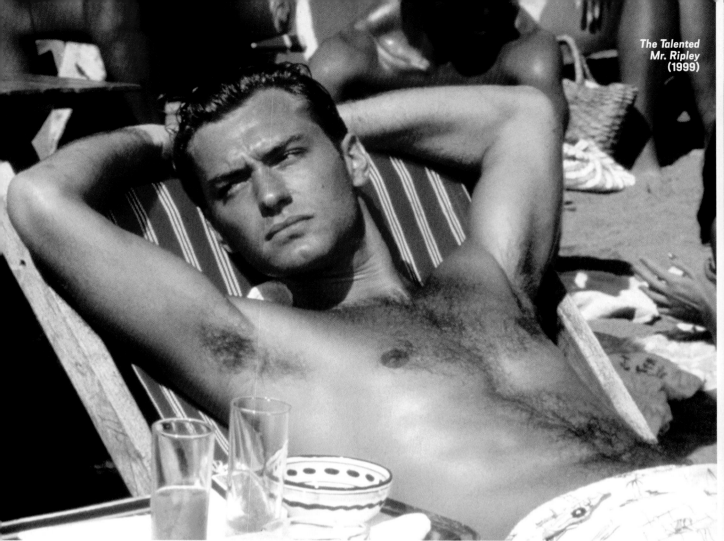

"His warmth is what makes him sexy, and it radiates through his eyes"
—NICOLE KIDMAN

WHEN JUDE LAW MADE THE daytime talk show rounds last year, even the pros became tongue-tied. "It's *allll* good," gaga'ed Kelly Ripa, giving Law a lusty once-over. "Just say it, Jude," Oprah prodded. "Say 'I am dashing.'" Ellen DeGeneres touted him as a model for the nip-and-tuck set. "When men go to plastic surgeons to get their lips redone," she told Law, "your lips are the most requested." Then viewers turned voyeurs as she traced the outline of his mouth with her fingertips on a video monitor. But Law's allure extends far beyond the chat shows. "He's the most beautiful man who ever walked the earth," pronounced Naomi Watts, one of his many smitten costars.

Whether playing *Alfie*'s cad or *Cold Mountain*'s heartbreak hero, Law, 32, was "the most charming man you could ever hope to come across," Gwyneth Paltrow told PEOPLE last year as her then-6-month-old daughter cooed on her lap. "Apple is chiming in her approval! Jude has that effect on females of all ages."

And all states of wedlock. Last Christmas, Law, though still techni-

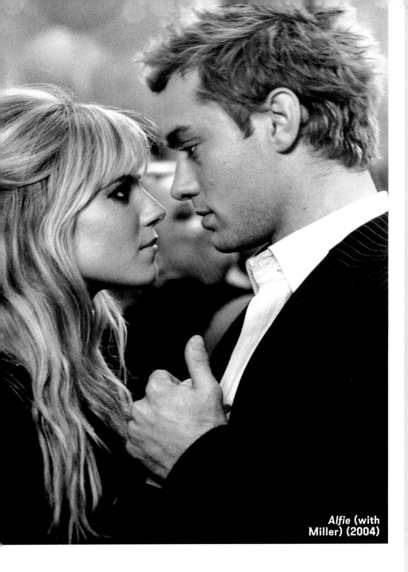

Alfie (with Miller) (2004)

"I said, 'You want to give me a little sugar for my birthday?' He leaned in and gave me a soft, sweet kiss on my cheek. . . . I walked away covered in goose bumps"
—COLUMNIST DEBBIE BANCROFT

"I still pinch myself when I wake up with him. He's such a gorgeous man"
—THEN GIRLFRIEND SIENNA MILLER

"When he's that bloody lovely, it's very hard to refuse"
—EX-NANNY DAISY WRIGHT

"He's pretty damn hot . . . and such a family man, and that makes your ovaries ache a little"
—ACTRESS ALYSON HANNIGAN

cally married to British fashion designer Sadie Frost, then 39 and the mother of their three children (their divorce became final six months later), presented girlfriend and *Alfie* costar Sienna Miller with a $35,000 engagement ring. The proposal made the 23-year-old actress feel, she said, like "the happiest girl alive!" The bloom, alas, was soon obliterated by a bombshell: In July, Law and Frost's former nanny Daisy Wright, 26, told a British tabloid that the previous March she had slept with her employer in New Orleans, where she and his children were visiting him on the set of *All the King's Men*. Law offered a public apology—and a de facto confession—saying he was "deeply ashamed and upset that I've hurt Sienna."

Since then it's been a roller coaster. Law pleaded with Sienna—who moved out of the London home they shared—to take him back, but, friends said, she had difficulty forgiving him. The couple's chances of reconciliation seemed high in September, when they were reported "continually laughing and joking" while shopping in London. In October their stock dropped precipitously: A source close to Law insisted "the relationship is over."

But was it *over* over? Days later the couple were spotted in Paris, and a mutual friend said they were still "smitten." The future? Stay tuned for the next episode of the real-life soap opera *Law & Ardor*. ▌▌

The Talented Mr. Ripley (1999)

WHO WAS SEXY IN
2004

Brad gets buff, Usher confesses, Hugh raises Helsing

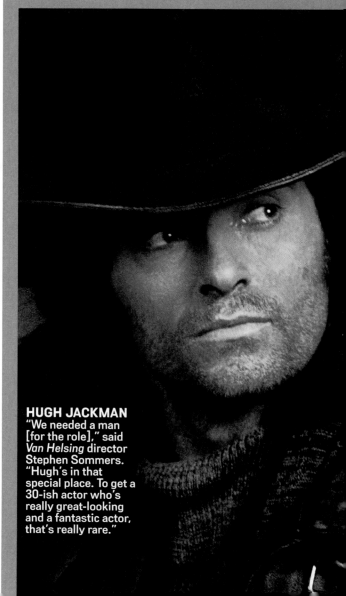

HUGH JACKMAN
"We needed a man [for the role]," said *Van Helsing* director Stephen Sommers. "Hugh's in that special place. To get a 30-ish actor who's really great-looking and a fantastic actor, that's really rare."

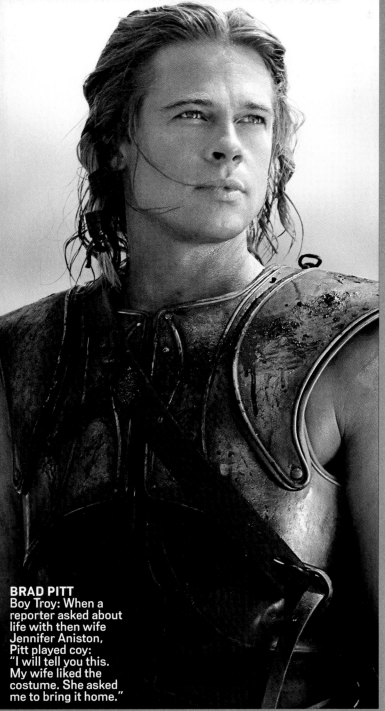

BRAD PITT
Boy Troy: When a reporter asked about life with then wife Jennifer Aniston, Pitt played coy: "I will tell you this. My wife liked the costume. She asked me to bring it home."

"He's tall. He's like 6'1". It's irritating"

—GEORGE CLOONEY, PITT'S 5'11"
OCEAN'S TWELVE COSTAR

Good news for normal mortals: Even the hottest have an off day. (Or decade?)

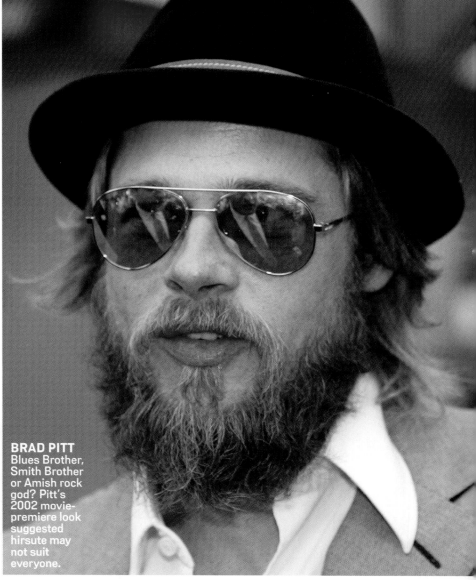

BRAD PITT Blues Brother, Smith Brother or Amish rock god? Pitt's 2002 movie-premiere look suggested hirsute may not suit everyone.

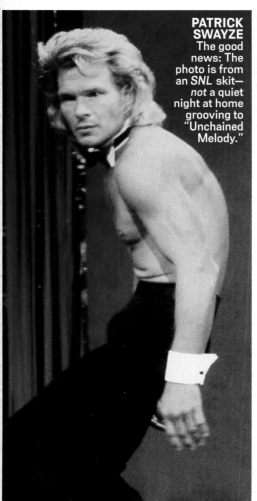

PATRICK SWAYZE The good news: The photo is from an *SNL* skit— *not* a quiet night at home grooving to "Unchained Melody."

ITS HARD TO BE SEXY 24/7

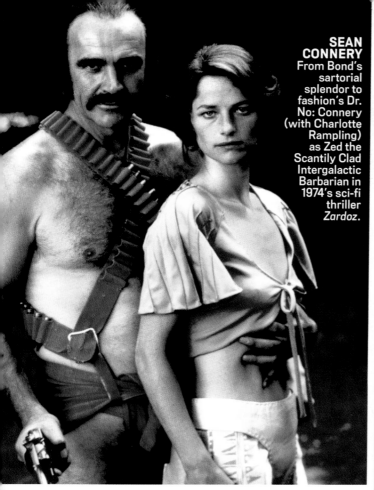

SEAN CONNERY
From Bond's sartorial splendor to fashion's Dr. No: Connery (with Charlotte Rampling) as Zed the Scantily Clad Intergalactic Barbarian in 1974's sci-fi thriller *Zardoz*.

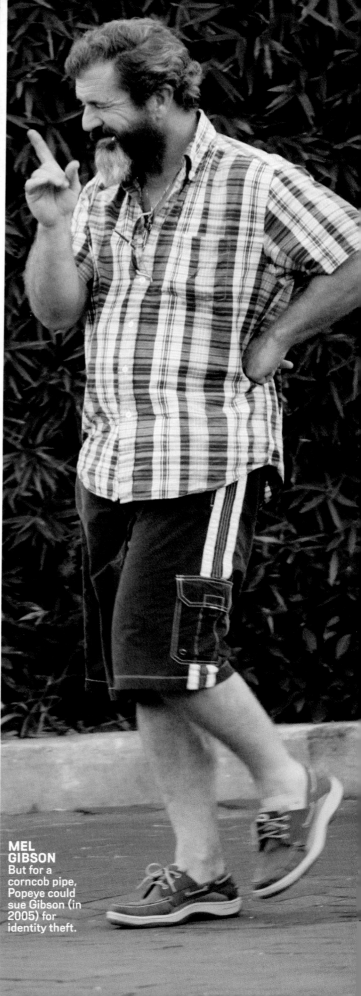

MEL GIBSON
But for a corncob pipe, Popeye could sue Gibson (in 2005) for identity theft.

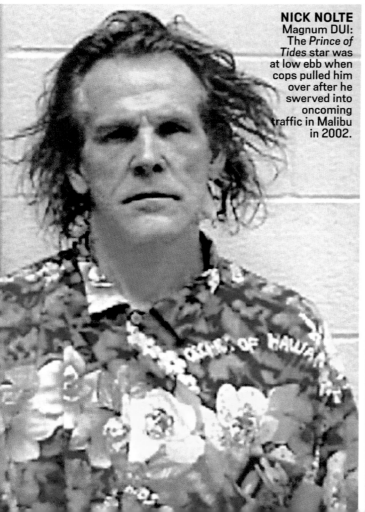

NICK NOLTE
Magnum DUI: The *Prince of Tides* star was at low ebb when cops pulled him over after he swerved into oncoming traffic in Malibu in 2002.

CREDITS

QUOTES
16-17 Lime Foto (2); (bottom right) Photos 12/Polaris; **18-19** (from left) Paul Adao/New York News Service; Steve Ellison/Shooting Star; David Appleby/Paramount

MEL GIBSON/1985
20-21 Ken Regan/Camera 5; **22-23** Everett (3); **24-25** (clockwise from top left) Globe; Columbia Pictures/Everett; Time Life Pictures/Getty

MARK HARMON/1986
26-27 (from left) NBC, Steve Harvey/Shooting Star; **28-29** (left) Paramount/Kobal; Everett

HARRY HAMLIN/1987
30-31 (left) Gene Trindl/Shooting Star; **32-33** (clockwise from top left) Paramount TV/Kobal; 20th Century Fox/Everett; Orion Pictures/Everett

JOHN F. KENNEDY JR./1988
34-35 Ron Galella/WireImage; **36-37** (left) Brownie Harris/Corbis; Paul Adao/New York News Service; **38-39** (from left) Victor Malafronte/Celebrity Photo; Paul Adao/New York News Service; Russell Turiak/Getty; **40-41** (clockwise from top left) Orion Pictures/Everett; 20th Century Fox/Kobal; Paramount/Everett

SEAN CONNERY/1989
42 Everett; **44-45** (from left) Sunset Boulevard/Corbis Sygma; Richard Melloul/Corbis Sygma; Everett; Corbis Bettmann; **46-47** (from left) Neal Preston/Corbis; Warner Bros/Everett; Lucasfilm/Paramount/Kobal

PUCKER UP, PRETTY BOY!
48 Lime Foto

TOM CRUISE/1990
51 Lance Staedler/Corbis Outline; **52-53** (left) Warner Bros/Everett; Sam Jones/Corbis Outline; **54-55** (clockwise from top left) Everett; Paramount/Everett (2); TriStar/Everett; Everett; **56-57** (clockwise from top) Kobal; ABC/Photofest; Buena Vista/Everett

PATRICK SWAYZE/1991
58-59 Jonathan Exley; **60-61** (from left) Lime Foto; Artisan Entertainment/Everett; Paramount/Kobal; **62-63** Everett (3)

NICK NOLTE/1992
64-65 (left) Jurgen Vollmer/Columbia Pictures/Photofest; Lime Foto; **66-67** (from left) Larry Watson/Fox/Photofest; Co Rentmeester; Frank Connor/Morgan Creek/20th Century Fox/Kobal

RICHARD GERE & CINDY CRAWFORD/1993
68-69 Steve Granitz/WireImage; **70-71** (clockwise from top left) Ken Regan/Warner Bros/Photofest; Warner Bros TV/Kobal; TriStar/ Everett

WHO IT SHOULD HAVE BEEN/1994
72-73 (clockwise from top) 20th Century Fox/Kobal; Amblin TV/Warner Bros TV/Kobal; Paramount/Everett; Miramax/Everett

THE CLASSICS
74-75 (clockwise from top) Buena Vista/Everett; Kobal; Universal/Photofest; Walt Disney Co./Everett; MCA/Universal/Everett

BRAD PITT/1995
76-77 Dimension Films/Everett; **78-79** (left) Time Life Pictures/Getty; MGM/Kobal; **80-81** (from left) Columbia Pictures/Everett; Everett; MGM/Everett; **82-83** (clockwise from top left) NBC/Everett; Columbia Pictures/Everett; 20th Century Fox/Everett; Warner Bros/Everett; Mark Seliger/ABC /Everett

DENZEL WASHINGTON/1996
84 Lime Foto; **86-87** (from left) TriStar/Everett; 20th Century Fox/Everett; Warner Bros/Everett; **88-89** (clockwise from top) Miramax/Everett; Warner Bros/Everett; John Atashian/Corbis; TriStar/Everett

GEORGE CLOONEY/1997
90-91 Michael O'Neill/Corbis Outline; **92-93** (from left) Universal/Everett; 20th Century Fox/Everett; Charles S. Hodes/NBC/Photofest; **94-95** (clockwise from top) Peter Sorel/Monarchy/Regency/Kobal; TriStar/Everett; 20th Century Fox/Everett; Miramax/Everett

HARRISON FORD/1998
97 Timothy White/Corbis Outline; **98-99** (from left) 20th Century Fox/Everett; Columbia Pictures/Everett; Michael O'Neill/Corbis Outline; **100-101** (clockwise from top) 20th Century Fox (2); MOV/London Features; Naomi Kaltman/Corbis Outline

RICHARD GERE/1999
102-103 Lime Foto; **104-105** (left) Terry O'Neill/Getty; Paramount/Kobal; **106-107** (from left) Everett; Buena Vista/Everett; Paramount/Everett; **108-109** (clockwise from top) Everett; Keith Hamshere/Lucasfilm/20th Century Fox/Photofest; Getty

SEXIEST IMPORTS
110-111 (clockwise from bottom left) Carlo Allegri/Getty; Piers Hanmer/Corbis Outline; Lorenzo Agius/Exclusives by Getty; Greg Endries/JBG Photo; David Bailey

BRAD PITT/2000
112-113 (left) Lime Foto; 20th Century Fox/Photofest; **114-115** (from left) Leslie Sokolow/LaMoine; Jaap Buitendijk/Universal/MPTV; Greg Gorman/Icon Intl

PIERCE BROSNAN/2001
116-117 Cristina Estadella/Corbis Outline; **118-119** (from left) MGM/Kobal; Everett; United Artists/Everett; **120-121** (clockwise from top) CPi; Columbia/Everett; Warner Bros/Everett

BEN AFFLECK/2002
122-123 Tony Duran/Icon Intl; **124-125** (clockwise from right) Corbis Sygma; Columbia Pictures/Everett; Buena Vista/Everett; **126-127** (clockwise from top) Greg Williams/ Corbis Outline; 20th Century Fox/ Everett; Robert Erdmann/Icon Intl; Debbie Smyth/Retna

JOHNNY DEPP/2003
128-129 Nigel Parry/CPi; **130-131** (left) Damian Dovarganes/AP; Walt Disney Co./Everett; **132-133** (left) Miramax/Everett; Everett; **134-135** (from left) Jen Lowery/LFI; Lime Foto; Lester Cohen/WireImage

JUDE LAW/2004
136-137 Tony Duran/Icon Intl; **138-139** (from left) Phil Bray/Paramount/Photofest; Paramount/Everett; Everett; **140-141** (from left) Universal/Everett; Warner Bros; Mark Baptiste/Corbis Outline

IT'S HARD TO BE SEXY 24/7
142-143 (clockwise from left) Getty; Kevin Winter/Getty; 20th Century Fox/Getty; Ramey Photo; Reuters

FRONT COVER
(clockwise from top left) Nigel Parry/CPi; Vince Bucci/Getty; Michael O'Neill/Corbis Outline; Albert Sanchez/Corbis Outline

BACK COVER
(clockwise from top left) Ron Galella/WireImage; Cristina Estadella/Corbis Outline; Tony Duran/Icon Intl; Ken Regan/Camera 5; Lime Foto; Lance Staedler/Corbis Outline; Corbis Bettmann; Lionel Hahn/Abaca

Editor Cutler Durkee
Creative Director Rina Migliaccio
Art Director David Jaenisch
Senior Editor Serena French
Picture Editor Donna Cohen
Writers Diane Clehane, Steve Dougherty, Elayne Fluker, Moira Bailey, Chris Strauss **Reporters** Mary Hart (Chief), Lisa Helem, David Cobb Craig, Antoinette Y. Coulton, Charles Curtis, Vincent R. Peterson, Brooke Bizzell Stachyra, Charlotte Triggs, Ashley N. Williams, Marisa Wong, Jennifer Wren, Paula Kashtan (Intern)
Photo Assistant Donna Tsufura
Copy Editors Joanann Scali, Ben Harte, Alan Levine, Cristine Gonzalez, Tommy Dunne
Production Artists Michael Aponte, Nora Cassar, Denise Doran, Ivy Lee, Michelle Lockhart, Cynthia Miele, Daniel Neuburger
Scanners Brien Foy, Stephen Pabarue
Special thanks to Robert Britton, Jane Bealer, Sal Covarrubias, Margery Frohlinger, Charles Nelson, Susan Radlauer, Annette Rusin, Ean Sheehy, Jack Styczynski, Céline Wojtala, Patrick Yang

TIME INC. HOME ENTERTAINMENT
Publisher Richard Fraiman
Executive Director, Marketing Services Carol Pittard **Director, Retail & Special Sales** Tom Mifsud **Marketing Director, Branded Businesses** Swati Rao **Director, New Product Development** Peter Harper **Financial Director** Steven Sandonato **Prepress Manager** Emily Rabin **Marketing Manager** Laura Adam **Book Production Manager** Suzanne Janso **Associate Prepress Manager** Anne-Michelle Gallero **Associate Marketing Manager** Danielle Radano **Special thanks to** Bozena Bannett, Alexandra Bliss, Glenn Buonocore, Robert Marasco, Brooke McGuire, Jonathan Polsky, Chavaughn Raines, Ilene Schreider, Adriana Tierno, Britney Williams